Conscious Creativity

look, connect, create

PHILIPPA STANTON
@5ftinf

'Tell me and I will forget; show me and I may remember;
involve me and I will understand.' *Confucius*

Leaping Hare Press

Contents

Introduction

I was a single parent with a toddler, a mortgage and a cat. I had no money and no qualifications. The prospect of working all hours to pay for someone else to look after my son and still financially fall short led me to make a massive commitment to my creativity. It was all I had.

A very dear friend told me at the time that, because her family was comfortably off, she knew it had made them less creative. Her husband was incensed and argued that his job had not only facilitated but also supported each and every one of the family's creative pursuits, including his own! She turned to me as he stormed out and, with a twinkle, whispered, 'He knows I'm right though.' It was an enlightening moment which stuck with me, and was one of the reasons I felt I wanted to share my processes.

I've written this book as a sort of guide or springboard towards developing your own creativity in a very conscious way, a way of utilizing all your senses and everything around you. There are no hard-and-fast rules, secrets or techniques to unlock your full creative potential, but there are definitely exercises that can help you to look at and see what surrounds you in a different, deeper and more meaningful way.

You may feel apprehensive about embracing a new creative route; perhaps at some point in your life a teacher or family member told you that you were no good at art or that you're just a maths and science person. Maybe you sat with the high achievers working extremely hard while the arty types listened to the radio in the art room. I was thwarted by academia at school and felt very average. I loved classical civilization and art, and somehow thought my enthusiasm for the subjects meant that I would achieve high grades. It didn't. However, during A Levels, I *was* one of those arty types listening to the radio and I was lucky enough to have a life-changing teacher who unlocked my eyes, validated my creativity and made me do things I didn't want to do, thus pushing me out of my comfort zone.

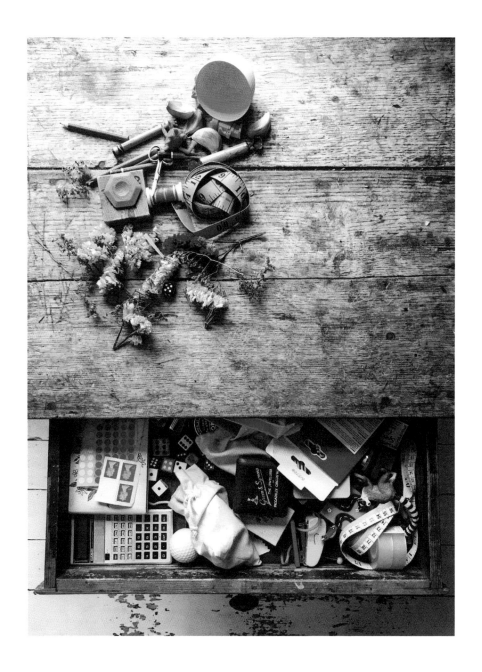

Some of you reading this will be innately creative, already armed with your own techniques and methods, hungry for new stimuli, new triggers and new ideas, but maybe you have just lost your mojo and feel a bit stuck. Some of you might have small children, limited time and energy, uninspiring jobs, no ideas and feel completely blocked. Regardless of where you have come from creatively, this book is intended to help you devise a personal structure for an ongoing creative practice with exercises you'll be able to revisit time and time again.

A simple awareness of your personal traits – good, bad, physical and emotional – means that you will be able to utilize or shelve them so as to work to your best ability. Developing an awareness of creative triggers will mean gaining a deeper and clearer way of looking, seeing and sensing everything around you. Our senses dictate how we interact with the world, although we rarely take time to consciously give them any disciplined space. A trip to a gallery or restaurant can give them a moment of indulgence, but the simple key to any creative inspiration lies in consciously taking the time to accurately acknowledge what is around us.

It's also important to make a genuine commitment to working on your creativity, but at the same time it shouldn't be something that eats away at your enjoyment and turns days of doing nothing into guilty secrets. Structure and commitment are crucial to developing your work, which is why I've used the first few chapters to try and help you define what sort of creative person you are as well as addressing universal obstacles.

Implementing your ideas is often much harder than just thinking about them: a lot of the time it's about being brave, facing your own notion of failure and finding a pearl of inspiration in what at first may appear to be total chaos. Although minimalism is popular, in this book I want to actively encourage you to embrace the joys of abundance and mess. Mess always sounds negative – a confused collection of unwanted clutter – but mess can also have texture and meaning, and can form a wonderfully accessible, and cheap, creative palette. The amorphous contents of a drawer which have been secretly shaming you might in fact turn out to be a creative liberation.

Although you could be working through this book at any time of the year, I want to acknowledge beginnings, as many people will probably find themselves reading this with some sort of 'new' resolve. Resolves always feel strong and positive at first, but that strength and drive often proves hard to maintain. However, in my opinion, it's that simple commitment that is key to your growth, not necessarily a constant and unfailing energy. If you feel rubbish, be rubbish, if you feel excited, be excited, but don't put pressure on yourself to 'get it right' or be 'good at it'. Experiment just to see what happens and push yourself to do things that challenge you.

I'm always taken by surprise at how unintentionally creative I start to become during a time of despondency. Feeling dreadful seems to unconsciously liberate me; I allow myself to let go of expectations, telling myself that it's all pointless anyway, and I begin playing around with ideas: old ones, new ones, regurgitated ones. I start to find a sort of secret and very personal way through my darkness and then slowly come out the other side.

We all work in different ways and that's as it should be. It's completely fine if you want to paint using kitchen utensils, write using felt tips or collage a piece of music. The point is, it will always be up to you; you were the one born with the power to invent.

Creativity is about discovering your own ways of working, your own unique practice, and growing the confidence needed to accept that. It's not about learning how to create something like everyone else, it's about learning how to acknowledge the true value of what *you* do.

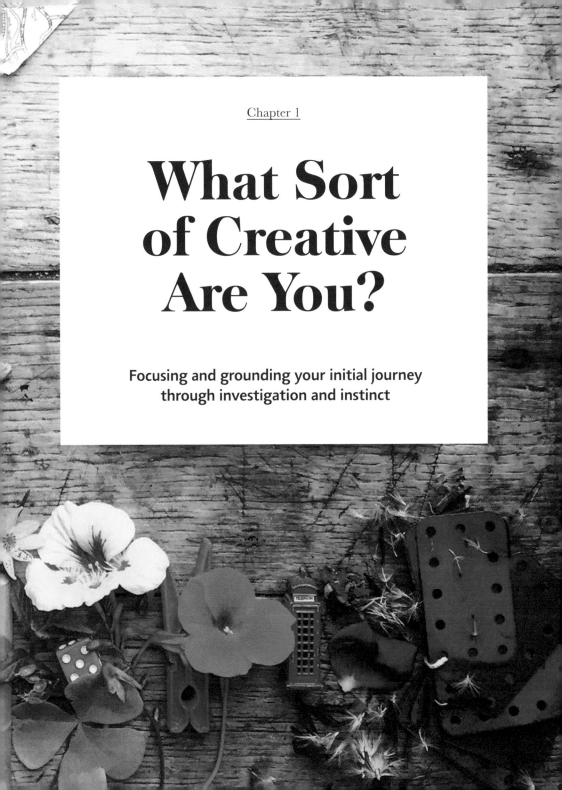

Chapter 1

What Sort of Creative Are You?

Focusing and grounding your initial journey
through investigation and instinct

Being creative and curious is a fundamental part of being a human being – we are all hard-wired to invent, explore and experiment – however, before you throw yourself into a frenzy of creative activity, it will be useful first to determine the type of creative you are.

You may feel intimidated by creativity or you may feel that you have it in abundance. You might feel you need to work out how to access your creative potential or you may think that you're not creative at all. You might even feel that all this focus on creativity is a load of nonsense. Working out what type of creative person you are does not mean you're making a decision that is set in stone, but it is something that will help you focus your initial journey.

As babies, creativity is our default setting, and at some point in our early development we will all have used our senses and instincts to survive and learn without the hindrance of intellectual analysis. Babies and toddlers are always exploring, putting everything into their mouths to investigate new textures, tastes and shapes. They develop their communication skills by trying out different sounds and they often discover their own sense of expression by simple mark making – sometimes with a lipstick all over the sofa or a felt-tip pen on a wall.

A baby will grab at a potted plant because it looks interesting and new. If it topples over and spills out they start playing with the soil, eating it, feeling it, pulling the remaining plant apart and sitting proudly in the centre of their efforts. What has been 'created' might seem to be a complete mess, but it's also an innocent and informative investigation. Artists and babies often both share that similar quality of freedom. They express themselves in ways relevant to who they are and how they feel. They make their marks and their sounds because they want to, because they're trying something new and have something they want to say.

Being creative isn't specifically about tuning into your inner child, but this book will encourage you to observe the world around you with a level of interest akin to that of a child. It's about reconnecting with the inquisitiveness, observation and instinct found in infancy, which we often lose sight of as we become adults.

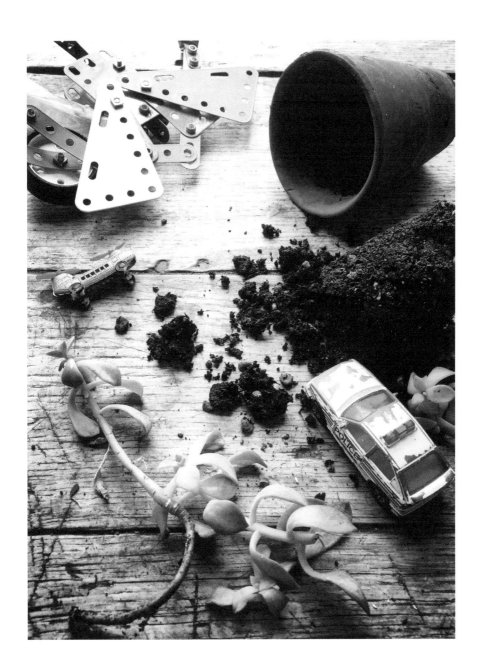

Before embarking on any course of action, it's always useful to question why you're actually doing it, what you'd like to get out of it and how you feel about it. Asking what type of creative person you think you are makes you consider yourself and your abilities and will help you to follow and develop a particular path or completely change it. Question what you think you already know and often your quickest and most instinctive responses will be the most insightful ones. The questions in this chapter are designed to enlighten you in a very simple way, rather than encourage any negative feelings, which can assassinate good ideas, particularly in their nascent stage.

There are no right or wrong answers here, it's just a very simple and personal investigation for you to reflect on and consider, and if more complicated thoughts or questions emerge, it will be interesting to think about those too. It's also useful to actually write your answers down, as a first commitment. Just thinking the answers in your head is an intellectual cop-out.

The type of creative person you view yourself as will probably change and develop over the course of the book, so to ask the question now means that you'll be able to compare your responses at a later stage. And finally, it's important to answer honestly and not in a way that you'd like to be perceived.

Questions always lead to more questions and inevitably end up with 'I don't know' and 'Why?', which are probably the best starting points for learning something new.

1. Is creativity important to you? Why?

2. Do you know or have a feeling as to what sort of creative person you are?

3. Do you consider yourself to be artistic?

4. Do you consider yourself to be practical?

5. Do you consider yourself mathematical?

6. Do you consider yourself scientific?

7. Do you consider yourself a words person?

8. Are you more logical, more random or a combination of both?

9. Do you consider yourself to be imaginative?

10. Do you accumulate, collect, or are you more of a minimalist?

11. Do you enjoy procrastination or does it make you feel guilty?

12. On the whole, are you a more precise person or a rougher 'that'll do' person?

13. Do you start more things than you finish?

14. Are you persistent or do you give up easily?

15. Do you ever feel guilty about time spent doing nothing if there are lots of jobs to be done?

16. Do you get nervous about getting things wrong and if so, do you know why?

17. Do you make a record of ideas, and if so, how?

18. What do you feel instinctively are your creative weaknesses?

19. Where do you feel, instinctively, that your creative strengths lie?

20. Has anyone ever told you or made you feel that you aren't good at art?

Ever since I was a child, I've always had lots of questions, and still do, often to the irritation of family and friends. When I was little our *Young People's Encyclopaedia* was always quickly exhausted. For example, it couldn't answer 'What is that jelly stuff inside a bubble of seaweed called?' As there was no internet, I'd have to ask my parents and brother all my questions and after a while my mum would often say, 'Actually, I don't know. Shall we go to the library and look it up?' You assume that your parents' knowledge will never run dry, but my mum would not only admit that she didn't know something, she would actively show an interest in discovering an answer.*

Not knowing something is a brilliant route to creative discovery and even though nowadays we can look things up quickly online, how we find those answers and what those answers then lead us on to discover is a fascinating wormhole of creativity in itself.

Like any other discipline across the board, creativity is something that needs to be practised and exercised; the more you engage with the practice, the more you will get from it, and you will learn to trust your own way of doing things and your own way of seeing the world. Even if you feel chaotic, underprepared and unproductive at first, experimentation and questioning are never wasted and everyone, at any level, needs to practise. Doing things you don't want to do, or don't like, will often prove far more productive than constantly focusing on the things you find easy. The great thing about creativity is that pushing boundaries is so accessible and solutions are infinite.

We are all drawn to particular aesthetics and we each have feelings about how things should look or be done, even if we don't know why or how to do them ourselves. We all have our preferred colours, fabrics, buildings, interiors, landscapes – all of which personally resonate with us. Most of the time those aesthetic preferences are taken for granted and not picked apart; it's just something we live with and know.

*Apparently the stuff inside seaweed is called 'agar' and not 'bingle', which was the name my brother invented to keep me quiet.

As a synaesthete my relationship to words and numbers also connects to aesthetics. Synaesthesia, which is very basically a merging of the senses (and which you'll discover more about in Chapter 7), opens up a sort of parallel world of inner abstraction. I can attribute moving forms, shapes, textures and colours to my sensory experiences as well as other concepts like maths and musical notation. For me the number '2' is a sort of golden yellow colour. '7' is also yellow, but a lighter shade with a bit of white inside and a bright sort of glowing edge.

All my numerical colours are important to me, although as my mathematical father regularly pointed out, have absolutely no relevance to any answers. I was never good at maths. I was far too interested in the shapes and colours of the questions. My processing never seems to be logical; it's long-winded and overly colourful. But I've worked out over the years that this is basically who I am, and I have to live and work with that rather than trying to change it.

I would argue that taking time to consider our personal aesthetic preferences is key to grounding ourselves creatively. Knowing what your likes and dislikes are, along with your strengths and weaknesses, is a really safe base from which you can explore and dare yourself to experiment.

So, here are a few more questions to help you think about some of your own aesthetic and creative preferences:

1. *What is your favourite colour?*
2. *What sort of colours don't you like?*
3. *Are you drawn to more colourful or more muted tones?*
4. *Do you have a sense that numbers, words or musical notes have colours?*
5. *Do you enjoy patterns?*
6. *Do you enjoy order?*
7. *Are you drawn to more traditional or more contemporary images and design?*
8. *Do you prefer sitting quietly in dark or bright spaces?*
9. *What sort of images appeal to you?*
10. *Do you often feel curious and let your mind wander?*
11. *Do you enjoy taking photographs?*
12. *Do you feel drawn to textiles?*
13. *Do you enjoy the theatre and plays?*
14. *Do you enjoy the cinema and film?*
15. *Do you enjoy visiting galleries?*
16. *Do you get a lot out of museums?*
17. *Do libraries make you feel comfortable or awkward?*
18. *Do you enjoy live music?*
19. *Do you enjoy being outdoors?*
20. *If you can't already, do you wish that you could draw and if 'yes', why?*

Structure, Practice and Obstacles

Ways of working to give you a sense
of aspiration and achievability

When I was about eight I started piano lessons. I'd watched people skilfully playing old familiar tunes and effortlessly entertaining at parties and I wanted to be able to do the same. It looked fun, and piano lessons also meant that I got out of a maths class every Thursday. I initially felt motivated, but it quickly became apparent that I had no natural talent and was totally incapable of any kind of practice. Rather shamefully, learning to play the piano bored me.

My mind would wander; middle C was a beautiful green, A flat a rusty, textured red and F was sort of hollow light blue.

Perhaps if music had been written in colour I would have been more interested in working out how to play. However, my boredom and my wandering mind actually turned out to be the very things that pulled my creativity into focus.

This chapter is about encouraging structure and developing new creative habits to help your creative practice, but first I want to look at some of the obstacles that can often hinder new beginnings.

Chapter 1 will have given you a good idea, or outline at least, of your approach and the type of person you are, so this chapter will aim to steer you towards a non-pressured way of working that can help give you a productive anchor.

Working with a structure in place, even if it's just this book, can create a sense of security as well as a sense of achievability. Rather than a solution, a structure for your creativity should be regarded as a personal aid, something you can let go of, reinvent and revisit time and time again if you want to. Even a very simple plan is a reassuring point of reference, guiding you through mental clutter, acting as a great springboard and becoming a stimulus for creating new work. In the long term, it will actually be the departure from the structure that will lead to a deeper development of your own creative practice. The time will come when you allow yourself to veer off plan, step away from your safe zone and totally engage with your burgeoning curiosity.

Personally, I like to have visual structures in place; I need to see things in front of me, constant reminders to stay on track and do things, and they usually appear in the shape of a handwritten list and sticky notes. I've always been a massive list writer and they can vary enormously, spanning 'beautiful places I must see' and

'painting project ideas' to 'domestic appliances that need to be fixed'. But I always spend time thinking about how I need the list to look, what its purpose is and how motivational I need it to be. Sometimes I even design them specifically to appear loud.

There is no definitive way to create your personal working structure as everyone is so different; I work in quite a chaotic, childlike way, for example, even though my fantasy version of me works in a calm, minimalist way. You might be someone who works best with neat and tidy order, but with a fantasy about the excitement of allowing some chaos into your life. Whichever way you lean, allow yourself to lean that way, but always keep your fantasy or ideal on your shoulder. Your structure or plan should contain both aspiration and achievability, and I will help prompt you in directions that feel comfortable, fun and not remotely intimidating.

The purpose of the first 20 questions in the previous chapter is to try and help you gain a bit of personal insight. For example, there is nothing necessarily wrong with procrastination, and in fact it is part of the whole creative process, but feeling guilty about it will only serve to assassinate fermenting creative ideas. Obviously there will always need to be a cut-off point when you actually dare yourself to do something, but there is actually a lot to be gained from time spent cleaning the cooker. Conversely, if you are always leaping straight into doing, you may need to develop the ability to procrastinate and slow down time.

The internet may be able to keep on giving us more and more 'stuff' ad infinitum, but our brains don't function like that. Our brains function in a much slower way, and connecting to our creative side involves inhabiting time in a capacity that is at odds with our standard perception of how we think it flows.

The second 20 questions are designed more towards engagement with creative and enjoyable stimuli; helping you to recognize places that make you feel comfortable, activities you enjoy and things you like looking at. All of these elements should play into your structure of practice, as practice is about absorbing inspiration and information as much as any actual 'doing'.

My singing teacher at RADA rarely told me to practise, but he did encourage me to listen to music I was unfamiliar with. At the end of my first summer term he told me I should listen to Maria Callas, who at that point I had never heard of, singing 'Una Voce Poco Fa'. I got the music from my local library and spent the whole summer singing along to a tape in my 2CV on my way to work. When I arrived back to class in September, I could reach top C. I had no idea that I could sing and it became so exciting that I would get to college at 8:30am every morning just to practise. My teacher had not only seen my potential, but had also acknowledged that I needed to take inspiration from somewhere or something. The structure that had been the springboard to a commitment to practise had simply been listening to unfamiliar music along with a gentle prompt and genuine encouragement. It can be as simple as that.

'We are enriched only by frequenting disciplines remote from our own.' *E. M. Cioran*

Exercise:

- *Write a list of five places you like, five pieces of music you like, five artists you like and five countries that interest you.*
- *Visit two places near where you live that you've never been to before.*
- *Listen to some music recommended by a friend.*
- *Write a list of things you have always wanted to do.*

Time

Time holds a very particular place in creative practice. When you're working on a project it often feels like one moment you've just had breakfast and the next moment you need to make supper. Time loses significance in the act of doing. Hours can feel like minutes in a burst of productivity, yet minutes can feel like hours in times of defeat. Time goes too quickly with an old friend and too slowly with an old bore.

Time is something we all have to adhere to, but which is impossible to actually observe. We are only able to observe time in the context of space and things, nature and growth, and it's important to ascertain your own relationship to time. Whether you enjoy being totally immersed in an activity without interruption or if you have a tendency to be more time-specific, it is crucial in both cases to allow yourself periods free from the standard constructs of time. For some it will be space to work freely and comfortably, and for others it will be an exercise in letting go of any guilt felt about time spent alone just to do something you love. Allowing yourself to become part of time and space with a simple, enjoyable, solitary activity can feel luxurious, but these time slips are definitely something to be encouraged and they always leave you with a sense of pride that you have been totally engaged in an activity. Rather than the world passing you by, in these periods, the world comes to you.

Exercise:

- Buy a small potted plant (but not a cactus). Watch it and take notice of it at some point every day. Water the plant and care for it. Observe what happens to it over a period of time and when it has significant turning points. If it dies, acknowledge how quickly or slowly that happened and if you know why.

- Watch an ice cube melt, in silence and on your own.

- Empty your cutlery drawer completely. Wash and dry it all by hand and then put it back.

- Complete a 500+ piece jigsaw.

'The dance of nature does not develop to the rhythm kept by the baton of a single orchestra conductor: every process dances independently with its neighbours.' *Carlo Rovelli*

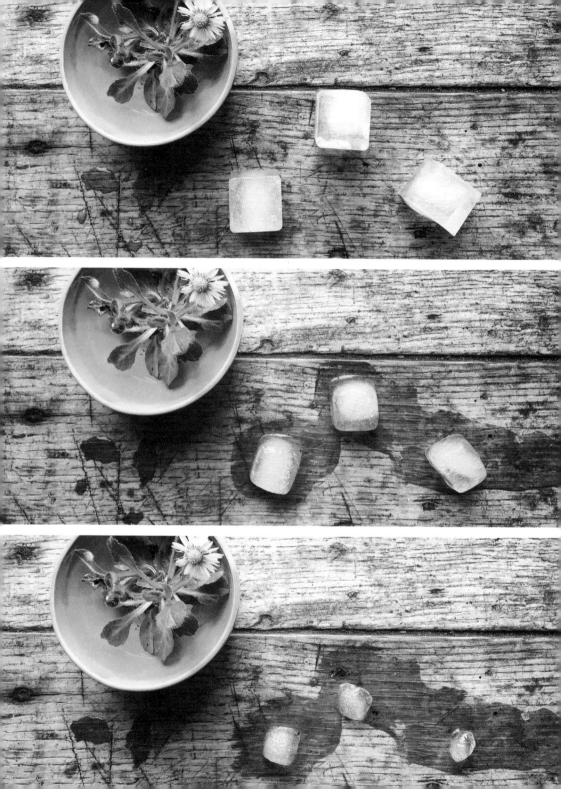

Boredom

Boredom is an integral factor in the creative process and one not to be ignored. Our minds are regularly tied up, often on our devices, and as constant stimulation leaves no space for idle thought, who knows whether some of our greatest ideas have already been pushed aside while we were gaming or checking social media?

The German word for boredom is '*langeweile*' meaning 'long while', which seems very appropriate, as boredom is essentially about nothing other than our interaction with time passing. However, boredom provides the exact nothingness in time that allows our minds to wander and invent. Unlike meditation, where you concentrate on keeping your mind focused and away from escape, boredom concentrates on seeking the most creative exit. Various synonyms for boredom include: weariness, lack of enthusiasm, lack of interest, apathy, sluggishness, frustration, languor, dissatisfaction, restlessness, tediousness, dullness, monotony, repetitiveness, flatness, blandness, sameness, routine and dreariness, and I can honestly say that I have felt *all* of these things during the creative process, particularly when I'm working on a painting.

Apparently the scientist Galileo was bored during a religious service in Pisa. He started to measure the duration of the oscillations of the cathedral's giant chandelier by counting the beats of his pulse. By letting his mind wander, he had discovered a way to measure time.

'When you pay attention to boredom it gets unbelievably interesting.' *Jon Kabat-Zinn*

Once you acknowledge that boredom can play a meaningful part in your creative journey, the most tedious of jobs – like washing up, cleaning or queuing – will show you that they nurture motivation and some of your best creative sparks.

It may seem counterintuitive to set yourself the task of being bored, but I suppose it's actually more about finding those moments that allow the boredom through. A lot of those moments exist in periods of waiting – time spent in a sort of limbo before something happens. Whether you're waiting for a bus, in a doctor's waiting room, in a traffic jam or outside the school gates, it's these boring times that make you reach for your phone. The task is to resist your device, focus on your boredom and engage your senses.

Exercise:

- *While waiting somewhere, count how many things you can see around you of just one colour.*
- *Listen to all the different sounds you can hear, make a mental list of them and acknowledge any that surprise you.*

- *How many different smells can you identify around you? Try and recall the smells of things you can see, even if it's just in a picture (a photograph of a pine forest, for example).*
- *Count how often you think about taking out your phone.*

Comparison assassination

There is a lot written about comparison at the moment, as it is becoming increasingly obvious that social media is a powerful engine fuelling negative comparison and low self-esteem. We find ways to evaluate ourselves through comparison, but we don't usually come out on top. Comparison has always been around, but it currently seems almost impossible to avoid. Social media feeds us with what is most detrimental to our personal accomplishments and values, gaining influence with our addictive consumption of it. Looking at other people's lives and work can be incredibly inspirational, but we have to be in the right frame of mind to take it that way.

The Dutch have a word '*benijden*' meaning 'benign envy'. It refers to an envy that motivates you to self-improvement deriving from another person's impressive example. This is a positive take on envy, but it's easier said than done. Everything screams at you not to compare yourself to others but, quite frankly, it's inescapable and can very quickly lead to an awful creative atrophy.

Envy or comparison can make you doubt your own abilities, it's time consuming, it depletes your drive, muddles your inspiration and evaporates any confidence in something you felt was important to say. The success of others, both financial and creative, can become your own personal paralysis, even if they appear to be actively encouraging you to achieve your goals. Therefore, it is vital to acknowledge at the start of any creative process that this feeling is unfortunately an inevitability, but it is universal and perfectly normal.

The benefit of acknowledging it upfront is that you will start to recognize your own unhelpful patterns of response. This means that you will then be able to start thinking about strategies that can help to keep them at bay. Knowing how you are likely to respond will empower you to choose how you react. When we feel the approaching urge to compare, we need to be ready to turn the feeling on its head.

'I will not reason and compare: my business is to create.' *William Blake*

Cultivating your own honest identity is crucial. You can create an alternative 'social' identity, but you need to know who you are first, especially if you discover that someone else is doing exactly what you're doing, something that you thought was unique. A friend recently reminded me that every year cookery books come out in their thousands, many of them including exactly the same recipes. But it's not the recipes that define the content, it's the personalities behind them, their unique voices and experiences.

On the up side, comparison can also sometimes serve as an awakening of consciousness, something that actually highlights your own possibilities. You might experience a moment of '*benijden*' and your unique creative life can suddenly appear possible again. Ruminating on others' successes can sometimes mean, if you are steadfast, that you will be able to extract useful creative nourishment and humour that turns your insecurities into something new and full of life.

Exercise:

- *Make a short list of what it is you like about someone you've been comparing yourself to.*
- *Be clear and specific and notice if you recognize any patterns to your responses.*
- *If you can, draw something bold yet simple that represents how this person makes you feel.*
- *Screw the list up into a paper ball and play Keepy-Uppy with it for 10 minutes.*

Fear, insecurity
and getting it wrong

Nearly everyone, at some point, has felt fear and insecurity about getting things wrong. You look at something you've spent ages creating and start to think how rubbish it is and wonder how you could have got it so wrong.

I certainly think most creatives would be able to admit to fear and insecurity on a weekly, if not daily basis: What if everyone hates my work? What if I look like an idiot? What if people see who I really am? What if I have to go back to where I started? I don't think these feelings can ever be totally dispelled, so you have to cultivate an inner mantra of 'It doesn't matter', even if you don't quite believe it. Worrying that you're going to get something wrong implies that there must be a correct way of doing something that you are unaware of: that somewhere someone knows what this right way is and they're just waiting to see whether you do too, and will probably laugh at you if you don't.

'Getting it wrong' is so often tied up with personal fears, judgements and disappointments that we often wilfully use to justify not moving forwards. The fear of getting it wrong, getting rejected and feeling like a failure, multiple times over, is not something anyone wishes to bring on and embrace, but it is one of the realities of creative progression that we have to accept.

Setting out with excitement, inspiration, hope and expectation is absolutely how it should be, and when we start to feel fear, it can often just be excitement and adrenaline in disguise. Having worked in the theatre for years, the feeling of fear has always been something I've had to deal with. You spend weeks rehearsing, but when the house lights go down and the audience quietens, you're terrified. And why are you frightened? Basically because it's so exciting. Often, being scared of our own potential and power is the very thing that stops us from putting it out there. It can feel so much safer and easier to keep ideas tucked inside our heads.

It's also very hard not to allow recent disappointments to affect our insecurities, and to use past disappointments to numb ambition and stifle success. Inspirational 'failures' like Bill Gates, J. K. Rowling, Steve Jobs or Walt Disney are classic examples of the universal feeling that failure is not final, it is just process. You don't watch a football match to see every pass end in a fantastic goal. You watch it to see the struggle, the working out, the skill and the emotional failures that then lead to great successes. Whatever point you are at in your life, you have arrived there through a combination of successes and failures, so you should nurture your bravery and enthusiasm and try to accommodate your fears.

If you're feeling the fear, here are a few things that may help move you in a slightly different direction even if it's small. The two last prompts are impossible to get wrong.

- Make a list of five specific things you fear you might 'get wrong' when starting a new project.
- Make a list of five specific things you think you might 'get right' when starting a new project.
- Find a crossword in a paper. Read the clues but complete it in the way it makes you feel rather than searching for correct answers.
- Write out the 2 times table, but make each sum equal an object or a place instead of a number, for example: 2 × 2 = Paris or 2 × 6 = apple.

Burnout

I often suffer with burnout during January and February. The months leading up to Christmas are always my most productive and so I'm often left feeling completely wrung out after the New Year. Comparison assassinations start to creep in, then fear and insecurity followed by an inability to make any decision or do anything. I'm subsequently left feeling disgusted with myself for being so unmotivated and pathetic.

Creative burnout is something that will usually happen, at some stage, to most creative people. How long it can last depends on how you address it. If your imagination and creativity are overworked and strained they basically stop functioning properly. They need time, space and rest to recover. If a friend tells you they've taken up running, it's only a matter of time before their Achilles tendon starts playing up or plantar fasciitis has taken hold and they need to take a break. Injuries are a physical inevitability of exercising and burnout is a mental inevitability of creating. Both need recovery time.

Burnout can happen because you've been creating lots of work, often with great purpose and possibly huge responsibility. Your creativity becomes heavy, mistakes even heavier, and any initial sense of the happy accident, lightness and flow completely disappear. So this is the time you must let yourself off the hook. This is the time you don't need to be productive. And this is the time to feed your curiosity. Use it as your creative hibernation and rejuvenation.

During a burnout it's important to make small changes to your routine and maybe invent some new habits. This is the ideal time to make trips to museums and galleries with no purpose other than looking at lots of different things and maybe reading some facts. Your creative muse has probably been starved of stimulation and any genuine excitement has vanished. You need to feed yourself at this point with interesting information that your brain can later connect to lots of creative ideas or thoughts.

Visit places you wouldn't normally consider, as well as places you've always been curious about. If your go-to museum is usually arts-orientated, choose a science one. Try some food you've never eaten before, turn a simple physical activity into a conscious daily habit. Watch some foreign films, documentaries and read a book outside of your usual area of interest. All this should be for no particular purpose other than that of curiosity and investigation.

However, don't forget to do lots of things that you enjoy and are totally within your comfort zone. Imagine that you're a kid off school; you're not too ill to go and visit places, and you can always come home at the end of the day to be cosy and safe. This time of small efforts will definitely be inspiring for your creativity in some shape or form, and will undoubtedly move you forwards with a renewed appetite for developing and practising your own ideas.

Exercise:

- *Plan and visit at least three different museums or galleries over a four-to-six-week period.*

- *Draw something on a Post-it note every day for a month or longer.*

- *Cook a meal from scratch that you've never cooked before and share it with someone.*

- *Take at least a morning to vacuum your home; vacuum corners and places you have never looked at before.*

- *Create and personalize a month's calendar. Write one word every morning and one word every evening in the appropriate date place.*

Chapter 3

Looking

The unremarkable holds the potential for endless new ideas

'It is simply this: do not tire, never lose interest, never grow indifferent – lose your invaluable curiosity and you let yourself die. It's as simple as that.' *Tove Jansson*

After I enthusiastically decided to study art A Level I was almost instantly disheartened. My teacher told me, very early on, that my homework was 'dire' and that I would at least have to learn how to draw if I was to pass the exam. But it was this art teacher who changed my life.

She made me look at things I'd never seen before, observe colours I'd never noticed, and gave me skills of perception that I still use every day. She even taught me how to draw. What amazed me was that she didn't even appear to think she was imparting anything special; she was simply offering a formula.

It was the most exciting and creative time I'd ever had at school and it took me completely by surprise. I discovered a new confidence and a new passion that I hadn't even been looking for. When it came to the exam, everyone apart from me got a grade A. I got a B and have never felt more disappointed. However, I strongly suspect that my B grade has unintentionally served as a very active creative motor for more than 25 years.

This chapter introduces a method of observation and looking that is absolutely integral to unlocking creativity. Really paying attention to everything around you sounds simple, but it actually demands a level of curiosity and observation that most people are not used to exercising. And it takes time. But changing your perception of the world around you is incredibly exciting and insightful. It empowers you to see truth rather than assumed knowledge. The unremarkable becomes something that holds the potential for endless new ideas.

Lateral looking

I love the idea of Edward de Bono's lateral thinking: that there isn't just one vertical approach to problem solving, but that there are many creative ways in all shapes and sizes, directions and dimensions, of which you are both master and inventor. Edward de Bono originated the term 'lateral thinking' in 1967 and has described it as '*deliberate creativity*'.

'Something new always slowly changes right in front of your eyes – it just happens.' *William Eggleston*

Challenging your established mental patterns by deliberate provocation is a great way to arrive at new creative areas; thinking in slightly different ways, particularly when problem solving, is definitely a skill that can be taught, and there are plenty of exercises that can help to take your brain outside of its usual box. Personally, something that I love doing – and which feels fundamental to any creative, artistic or aesthetic practice – is to exercise my eyes in a more lateral way because we tend only to see what our brain tells us is there. Our eyes follow known patterns, patterns that we are used to seeing and, a bit like predictive text, our eyes sometimes don't get it quite right.

I have a favourite 500-piece jigsaw puzzle. My mother bought it for me years ago and I have always adored it. The puzzle is a treat that I only pull out every few years because I never want to get too good at it. The picture is a vast collection of multicoloured vintage buttons. The reds and greens are always the easiest to find, but the last time I completed it, I spent hours looking for the piece with a small grey button on it. It wasn't until there were only a handful of pieces left that I found it. But the 'grey' button was not grey: close up, disjointed and abstracted from its whole, this grey button was in fact green. My brain could see the grey button, but it didn't inform me that the grey was actually made up of different tones of green.

Getting things wrong and making errors so often turns out just to be an error of perception. Not only our minds but our eyes should also be encouraged and exercised to be as open as possible. Challenging our perception will always help us see and create in new and unusual ways.

Exercise:
- *Look in puddles and see what's reflected.*
- *Look at shadows cast by ceiling lights.*
- *How many colours can you see in an empty glass?*
- *Look at reflections in sunglasses.*

Curiosity

Curiosity, like boredom and time, has an ambiguity. It is the desire to learn or know about anything, and as a result, has vast and almost infinite scope. Historically, religion has railed against curiosity and it was always considered to be a vice: in the Garden of Eden, Eve ate and shared the forbidden fruit and as a result got both herself and Adam expelled. The story comes from an age that recognized and discouraged any yearning for learning, as curious minds would not be easy to manage.

In George Orwell's *1984* he depicts a future dystopic state where the Party claims that 'ignorance is strength'. It is intentionally terrifying. Your creative strength and power are directly informed by your curiosity, knowledge and exploration. If these are taken away, you cease to have your own voice. Keeping your curiosity active will always exercise your imagination. It's how ideas are fed.

When I was little, my brother was always looking under rocks, squeezing himself through dark and empty gaps, and scouring woodland for weird treasure. He was hungry for new adventure at all times and I was always frightened by it. My imagination would spiral out of control; I inevitably imagined far worse scenarios than anything he would discover. Curiosity has many guises and can be invaluable in an array of different areas. In a creative context, curiosity is a really helpful tool for discovering and noticing the complexities of the ordinary, and it will give you a firm foundation for much deeper observation and lateral looking if you are able to acknowledge the nature of what is right in front of you and keep questioning it.

Exercise:
- *Open a door you've never opened before.*
- *Look behind the sofa or under the wardrobe.*
- *Eat something you've never tried.*
- *Walk down a street you've never been down.*

'Curiosity . . . evokes the care one takes for what exists and could exist: a readiness to find strange and singular what surrounds us.' *Michel Foucault*

Observation

When I was at drama school in the early 1990s, one of the theatre directors asked a few of us to find our eye level on a wall opposite. We had to observe everything at that level while slowly turning 360 degrees over the course of five minutes. Afterwards he asked each of us what we had seen. For me the white wall was fascinating and I was actually excited to share my discoveries. It was a landscape full of cracks, scuffs, ageing sticky tape, shadows, pencil marks, small flecks and old chewing gum. It was far more than just a white wall. Looking at everything and recalling so much detail was genuinely enlightening. It focused my mind on apparently nothing, which then led to finding a great deal of something. The point of the exercise was that in acknowledging the depth of detail right in front of you, you will become more aware of the whole space around you.

Observation is one of the most important factors in creativity as it's not necessarily about having loads of ideas and producing loads of work; it is often just about seeing all sorts of everyday objects and occurrences and letting them feed your personal visual archive.

If your observations aren't topped up regularly, your ideas can start to feel stale, repetitive, bland and derivative. Spending time taking in your surroundings and consciously collecting new observations should be a fundamental and enjoyable part of your creative process. Allowing yourself to sit in a park or a cafe, just to look and listen and maybe even smell things, might feel like a massive luxury, but if you don't allow yourself the time to consciously observe, your creative mojo will almost certainly become starved.

Observational references will always lead to new ideas whether you like it or not, and those ideas will, in turn, start to resonate with some form of doing. Making notes of ordinary things will help them take on new meaning. The ordinary will always find a way of becoming the extraordinary: the memory of an old lady's coat hanging in a cafe, the sound of birds outside, the smell of coffee or the dry taste of a currant bun.

'Lie on the bridge and watch the water flowing past. Or run, or wade through the swamp in your red boots. Or roll yourself up and listen to the rain falling on the roof. It's very easy to enjoy yourself.' *Tove Jansson*

A few methods of looking that can enhance our observation include:

ABSTRACTING, which is a practice of visually defining objects by simplifying your view of their shape.

MATCHING, a practice of looking out for objects, forms or shapes that visually match others, but are functionally completely different.

COLOUR IDENTIFYING, a practice of identifying colours, particularly when at first glance you may not realize they are there.

PATTERN SPOTTING, the practice of consciously noticing and actively looking for patterns, no matter how random or abstract.

The greater awareness you have of these more abstract ways of looking, the more adept you will become at observing. I talk about these in more detail in Chapter 10.

When you're out:

- *Look up and find three things you've never noticed before, but that are always there.*
- *Look down and count the different types of surfaces underfoot, such as tarmac, paving slabs, cobbles etc.*
- *Look left and notice how colours punctuate your surroundings.*

- *Look right and notice shadows behind things.*
- *Look straight ahead and notice how much you can't see around you.*

Chapter 4

Documenting

Consciously collecting and organizing
your observations and inspirations

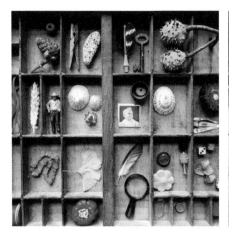

The more you consciously practise engaging your observational skills, the more detailed and meaningful they will become. Slightly altering and shifting your way of seeing and looking will start to form a very necessary, yet easy, part of your daily practice.

Over the next few chapters I set out specific areas that will help to form a foundation for your own creative exploration, and finding ways to document what you see and do will be hugely beneficial to your progress. Practice is essential to the development of a skill, but should never be something that fills you with dread. Exploring your creativity and practising it is a process; there are no exams to define your level of achievement, no grades, no passes, no fails, just continuing play and experimentation.

'Whatever the difference between brilliant and average brains, we are all creative. And through practice and study we can enhance our skills and talents.' *Jeff Hawkins*

How to document your ideas

Since the advances of mobile photography, my observations have worked hand in hand with visual collecting and documentation, and I take images on a daily basis. Visual collecting is a practice of taking time to consciously collect and document often small observations from your daily experiences that aren't necessarily always pretty, but which interest you. I use documenting constantly in my work and it always informs how I see and feel. My photos are like notes and sketches. It's not about selfies or self-promotion, it's not always about taking a great photograph, it's about accepting the mobile camera phone as an important creative tool. It's about finding and looking at details and not necessarily hitting on 'Instagram gold'. However, the best tool is always the one you're most comfortable using, so if you have a great DSLR you love, then use that. And you don't have to document with photography if you don't want to. You might prefer sketching or writing notes that will jog your memory later on. Remember, everyone is unique and everyone will approach documenting in a unique way.

Create some sort of place to document your work, somewhere you can chart your ideas, observations and even failures. Somewhere you will be able to look through and notice progressions, stagnations and moments you feel proud of. It is really important to 'do' something every day, so no matter how small, even if it's a new thought or something you've seen in a new light, make a note of it.

You can have a physical sketchbook, notebook, diary or cork board, for instance, to help collect thoughts, sketches, notes, photos, magazine cuttings, postcards and even bits and pieces you've picked up that you just like for some reason. You could also create a type of digital sketchbook: a dedicated memory stick, a folder on your computer, a specific social media account or image board, perhaps, or you could even create a very simple blog space. Although some of these are 'social' spaces, that is not how I would regard them in the context of your creative investigations. If you use them as a workbook you will be able to channel your observations and inspirations in a more focused way, and the act of organizing your creativity is a beneficial exercise.

I also always carry a pencil or pen around because inspiration very often takes us by surprise and your usual workbook may not be immediately to hand.

You could create a collection of what I call sketchbook threads: a combination of both digital and physical work that all weaves together, but that maybe doesn't all live together. If you use this method, it will be useful just to make a list of all the places you are storing work, for example, blue notebook, Instagram, pink memory stick and so on, so that it feels that you have at least created dedicated work spaces.

It's a useful exercise to regularly look back over all your experiments, notes and ideas so that they stay fresh in your mind and firmly rooted. I'm often surprised when I look back through an old notebook at how a rather insignificant idea I may have had two years previously is suddenly incredibly relevant.

Daily Practice: Take a walk

- Decide on a destination, even if it's as simple as a tree at the end of the road.
- Go out for a half-hour walk *without* your smartphone/camera, and on your own.
- Look at everything around you, don't just walk. Take notice of how you feel about it.
- Is the area familiar, boring, beautiful, ugly, ordinary, functional, colourful, dull, dirty or clean?
- While you're walking think about the reasons you like or dislike the area.
- Consider your presence in the space, but also consider the size of the space that surrounds you. Be conscious of your feet on the ground and the ground under your feet, your hands in the air and the air on your hands.
- Become aware of how all your senses are working. Have the same openness and interest that a small child would. Allow yourself to touch, hear and smell what's around you as it will help clarify your observations.
- Make a mental note of everything you want to take a photo of.
- Go back on the same walk on another day, *with* your camera, and allow yourself to take pictures of anything that interests you – a combination of new, different things and things you saw and felt on the first walk.
- Bring five things back home that you found on your second walk. Anything from a pebble or a rubber band to a leaf or a flower, but nothing from *inside*.
- Keep these five things in your home for seven days. Consciously look at them every day. Find new things to see. Watch how they change and how your attitude towards them changes over the week.
- Organize your observations into a weekly record.

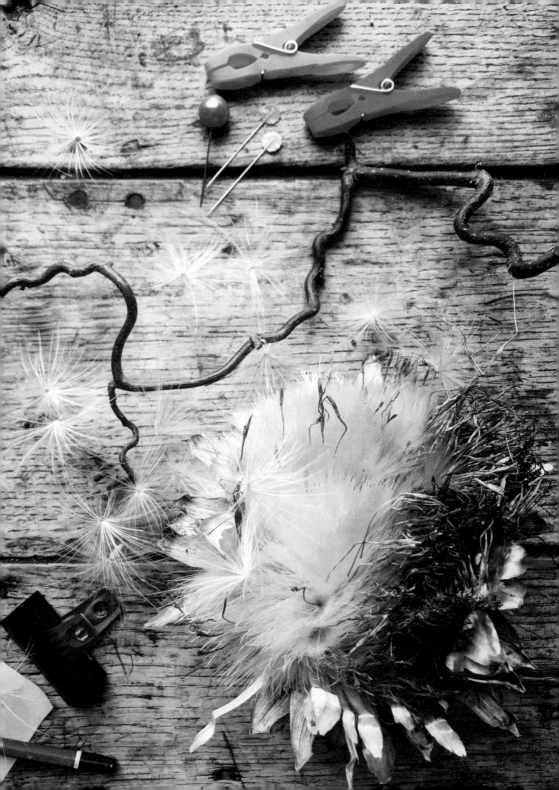

Texture and Wabi Sabi

Everything holds some sort of
imperfection and irregularity

As a point of aesthetic reference for texture, it is really useful to embrace or at least consider the Japanese concept of wabi sabi. Very simply, wabi implies a rustic simplicity – a quietness, freshness and irregularity – and sabi is about the beauty and grace that only become visible with age. Wabi sabi is a way of viewing the world that accepts the impermanence and imperfections of our surroundings and existence. Everything holds some imperfection and irregularity, either due to natural anomalies or just the simple weathering of life. Everything and everyone has a finite lifespan that eases us towards inevitable nothingness.

Contemplating our own existence with the knowledge of death's indifference can sometimes feel rather melancholy, but it can also be comforting: after all, we are all in the same mortality boat. Weathering, insignificance and disappearance are inescapable for anyone or anything. All of us, at some point, will succumb to it. Wabi sabi is not about the obvious beauty of the bloom of life, but it is about the visible signs of a whole life lived and on the brink of disappearance.

Spending time with something not conventionally beautiful, but rundown instead, maybe even what you consider ugly, can be incredibly enlightening, aesthetically exciting and inspiring. Thinking about its life, its past and what it may become is, in my opinion, an invaluable creative contemplation of time and life that will lead to a richer way of expressing yourself, and give you reason for seeing with new eyes. We are bombarded with images of beauty and perfection, but it is the images of real life and subtle imperfection that will always resonate with us more deeply.

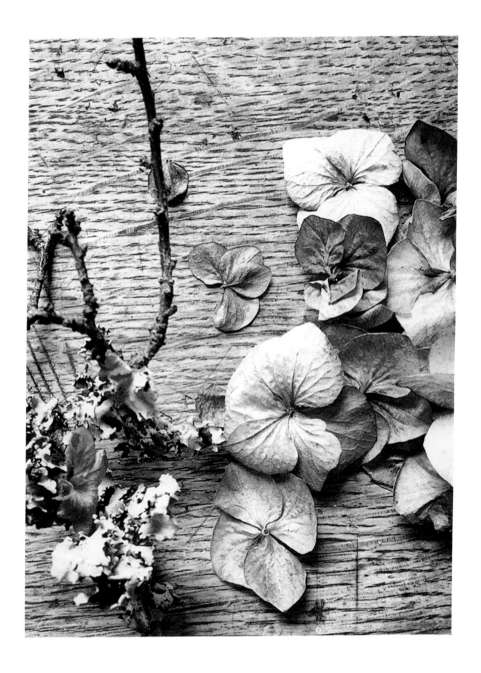

Identifying textures

Incorporating a sense of wabi sabi into your ways of looking will inevitably lead to the observation of textures. For me texture is the fundamental living and breathing element behind any composition, whether visual, verbal or aural.

Dictionary definition of texture: The feel, appearance or consistency of a surface or a substance.

Texture gives a sense of three-dimensionality to all things. It is tactile, alive and real, but also very abstract. Everything has its own patina and its own particular surface quality, but apart from some standard adjectives, texture as a whole is pretty tricky to define. It has an esoteric quality that can't be summed up by a dictionary definition.

Noticing the texture and the abstract around you, and engaging with detail on this level will help inform your visual vocabulary and give your compositions more depth and a sense of place. More often than not abstract art is about a felt response rather than an intellectual one, in other words, emotional responses, not ones that tick any accuracy boxes. This can be a difficult concept for people needing to understand things in a logical way, but a relief for people who struggle to find words to describe their feelings.

We are surrounded by textures, which can somehow make it easy either not to see them at all or to see them as ugly and functional necessities, meaning we can inadvertently disregard their potential. It's not often that we bend down to take a good look at the earth of a ploughed field, the stickiness of a chewed sweet stuck on the pavement or the crumbling wood in a tiny corner of a decaying window.

It's important to explore the nature of texture as well as documenting it; however, remember that it's important to spend time freely looking before any sort of doing. Simply using your eyes will always help to identify a sense of feeling beyond your observations, and then later it will also help frame them. You will be connected to your feeling response: the colours you saw, the warmth you felt and the way you experienced the moment.

 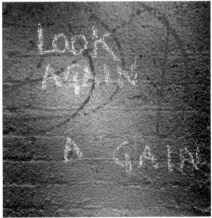

Daily Practice: Outdoor texture collection

- Collect about 20 abstract images of different textures over the course of a week.

- Notice the textures you are instinctively drawn to and the textures you maybe don't like as much, and think about the possible reasons why.

- Do any of the textures provoke memories of any kind?

- If you need a focused starting point, keep your eyes open for things that are: rough, smooth, spiky, furry, sticky, crumbly, flaky, shiny, soft and matt.

- At the end of the week choose eight favourites and save them all together as a record.

Collecting, experiencing and documenting outdoor textures can serve as great abstract inspiration for something we will possibly later create at home or in the studio. Nature provides a lot of crumbling and weathered texture, but it's not always practical or possible to bring any of it home to work with. However, we can recreate the feeling, the colours and sense of textures we've seen by using elements accessible to us indoors. There is plenty of texture to be found without leaving the house. Kitchen cupboards are some of the most fruitful places to forage for textures, although this also means you must prepare yourself to embrace mess.

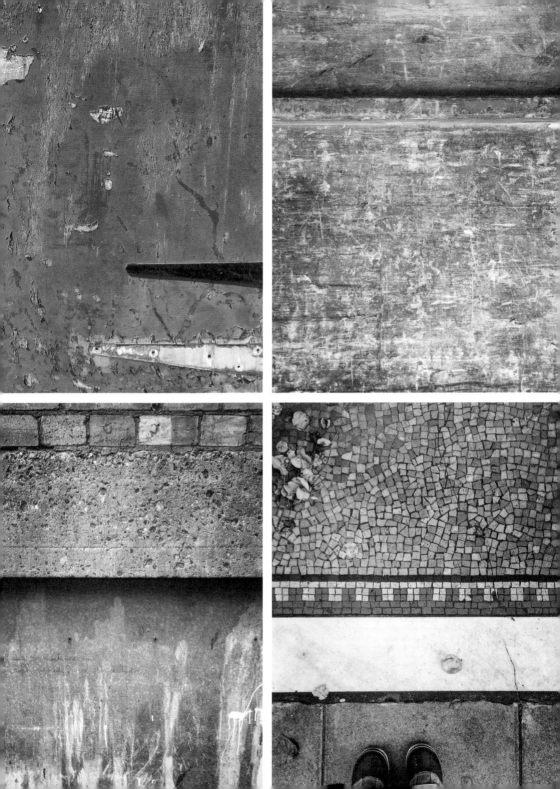

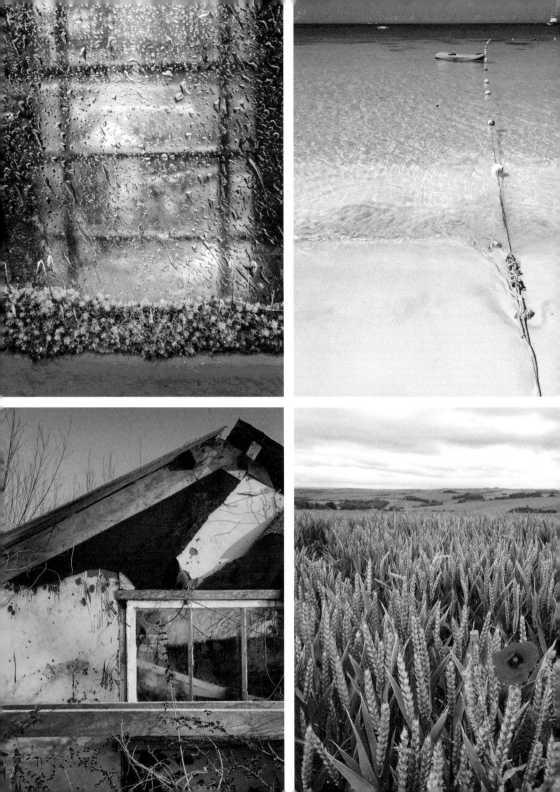

Daily Practice: Indoor texture exploration

- Collect five or six different herbs, spices or dry ingredients from the kitchen cupboard.

- Throw an amount of each one on to a chosen surface. Study their different consistencies, textures and colours. Look at the detail of their shapes, how they match, how they contrast, how they blend or clash.

- Play around with them; touch them, blow them, brush them, smell them, and notice how doing this makes you feel.

- Begin to use them, almost like paint, to create some sort of abstract textured image. The image doesn't have to mean anything; this isn't about creating a work of art, this is about exploring freedom.

- Feel the freedom and enjoyment of making a mess.

- Using your smartphone camera rather like a viewfinder, frame and take pictures of different sections of the mess you've created. Taking these pictures will allow you to see and focus on details, angles and sections within the composition that are easily overlooked.

Chapter 6

Colour

Appreciating the emotional and logical language
of colour and how you perceive it

U sing colour is about being able to really see colour and not just what you think it is, what you've learned it is or what you at first perceive it to be. Using colour creatively is about getting your mind and eyes to enter a vast universe of bright and subtle hues with infinite inspiring combinations and finding your own ways to indulge their individuality.

Truly seeing colours that are right in front of you demands a completely different level of visual engagement. It is one that leads you to a different kind of logic and gathering of information, as well as connecting you to your emotions. Colour isn't just some fun embellishment to life; colour is a different language that can be studied and learned, and that provides an alternative level of understanding and unspoken emotion.

Colour is a constant creative deceiver, a sort of humorous and scientific magician. Even if we're not aware of it, it constantly plays with our perceptions. What appears yellow may, on closer inspection, actually be brown. Light affects colour in different ways, as does the placement of certain colours next to one another.

Throughout history colour has been perceived in very different ways. In the Middle Ages blue was thought to be a hot colour and blue was also a colour that the Greeks made no reference to in their literature. In *The Iliad*, Homer famously

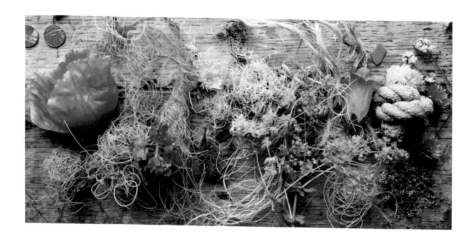

uses the metaphor 'the wine-dark sea', which is now thought to be a description encouraging us to think much more about the dangers and intoxicating effects of the sea rather than the colour of the sea itself.

As appreciating and observing colour is a bit like learning a new language, this chapter is about helping you to understand it more, enhancing your vocabulary and looking much more closely at colour in its everyday context.

We've already worked on being more observant when looking at our surroundings, seeing things in detail and utilizing textures, and now we can weave in a sense of colour to this process of exploration and practice.

Daily Practice: Perceiving colour

Josef Albers writes brilliantly about how colours can deceive and inform each other in his 1960s handbook *Interaction of Colour*, and he gives many examples of how you can experiment and experience his ideas using coloured papers.

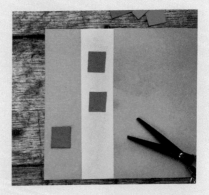

As a very simple exercise, cut out two small squares about 2.5 × 2.5 cm (1 × 1 in) of exactly the same coloured paper and then play around with placing them on different coloured paper backgrounds and see how this affects the hue of your cut squares.

Colour wheels

Colour contrasts are just as important as colour similarities, and often when I create a colour-based flat lay, what really lifts it is a contrasting colour, simply because it highlights the rest of the colour scheme. Making your own colour wheel can familiarize your brain with the colour spectrum and it also means that you will have a colour reference easily to hand. You can also play around with making a colour wheel by using different objects.

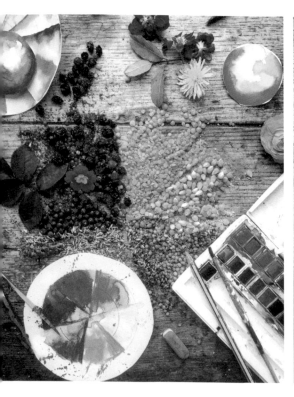
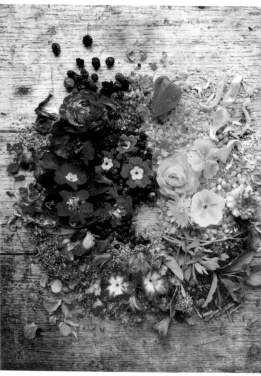

Colour collecting

Collecting colour through observation is another simple way to lead you into a daily practice of actually looking at what's around you and loosens up your 'noticing' skills. By introducing an activity, that of collecting, you bring a simple sense of purpose to the act of looking, which in turn means that you don't just look, you actively 'see' things.

There is always ample opportunity for colour collecting. Whether you're out on a walk or just doing chores at home, you will be surrounded by colours that most people don't even notice. Once you start 'collecting' them, this can become informative and incredibly satisfying. One of the best ways to notice and acknowledge colour around you is to start to familiarize yourself with it in an everyday way. Colour collecting is something that a camera phone is really useful for, because when a colour jumps out at you, perhaps when you're least expecting it, you have an instant way to 'capture' it.

Daily Practice: Outdoors

- When you're outdoors choose one colour to focus on for a day, or maybe even a week.
- Collect any observations of that colour that land in your field of vision: what appears at your feet, in a bush, above you, below you, in the corner of your eye, in the distance, right in front of you, behind you or anywhere else your eye is taken.
- Keep your curiosity alive and try to notice all the hues you can see of one colour in one object.
- It's important to document your finds. Using a camera means that you'll be able to look back on your photos and see how many hue variations you have picked out. This will then start to inform and grow your understanding of how you personally perceive colour. You can also write down or draw your observations, detailing the colour, the object, the material, the texture, what's around it, why you noticed it and any extra details you feel are interesting or important. Keep it simple though, because this is much more of an information-collecting exercise than an exercise in excellence. Starting a personal colour collection will enhance your appreciation of how far-reaching the colour spectrum is.

Daily Practice: Indoors

'Domestic foraging' is the name I came up with for a method that I utilize most during the winter months when there isn't as much obvious natural colour to collect outdoors. Domestic foraging is about looking at the colour of things in your own home: dried pasta, a soap wrapper, sticky tape, string for example – all seemingly pretty mundane things. It could even be things you've found down the back of the sofa or under the bed. These domestic bits and pieces will serve to help you create an indoor colour collection. Like the outdoor exercise, this is an information-gathering exercise in identifying colours rather than finding lots of beautiful things to show off, although obviously beautiful objects are not out of bounds.

- Again, focus on one colour for either a day or a week and then physically collect items that you find around the house all in that one colour.
- Keep the collection in one place for the duration of the exercise, adding to it as and when. At the end of the period of time, arrange everything you've collected in one place so that you can see the colour en masse.
- Arrange and rearrange the group of coloured objects in a way that feels right to you and then document it with either a camera, words, drawings or a combination of all three.

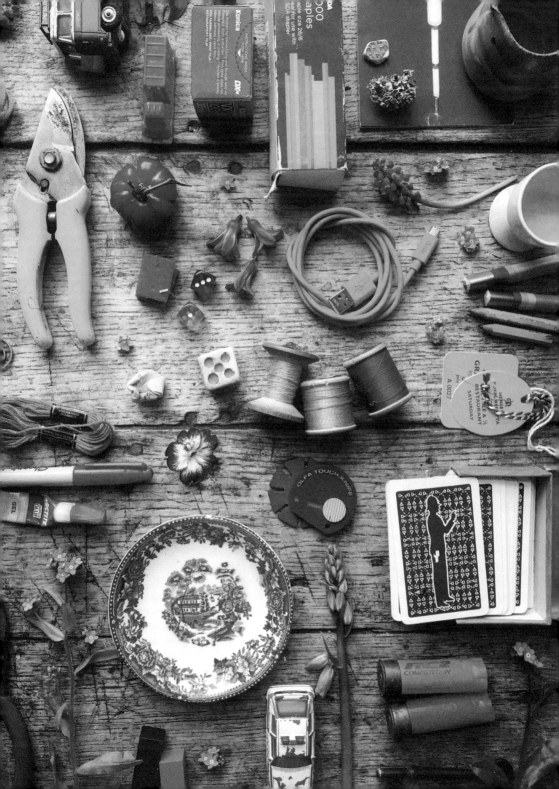

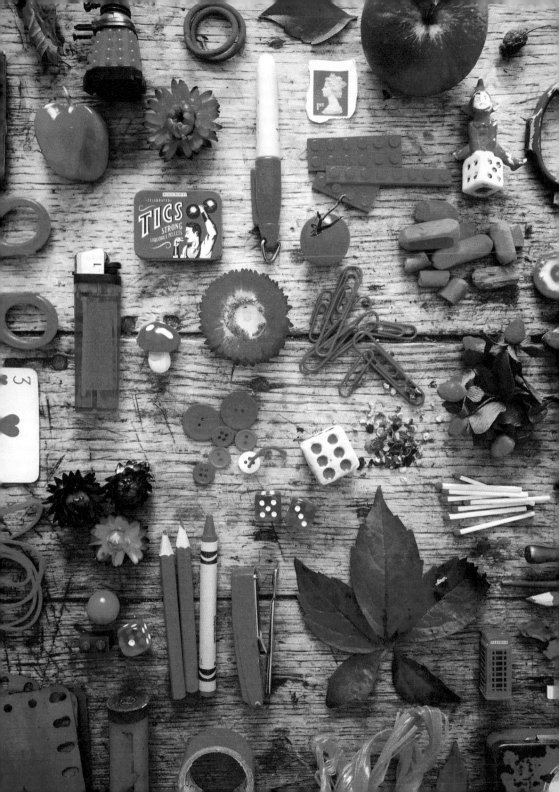

Create a colour essay

This exercise will give your observations a context and a story, and will work best for you if you've completed the colour-collecting activities first. It's an exercise to engage your imagination rather than ordering collected information, so focus on what sort of story colours can help to tell and imply. It can be abstract or linear, using words, pictures, collage, sounds or anything else you want to incorporate, but it should be created to show, in a very simple way, some of your experiences of colour throughout the week with at least seven images. If you have completed colour-collecting studies in all the primary colours, a good way of extending this would be to create a colour essay that charts your observations specifically in colour order.

The colour exercises in this chapter will serve to focus your creative imagination on elements observed in your environment that genuinely interest you and that also lead your imagination elsewhere.

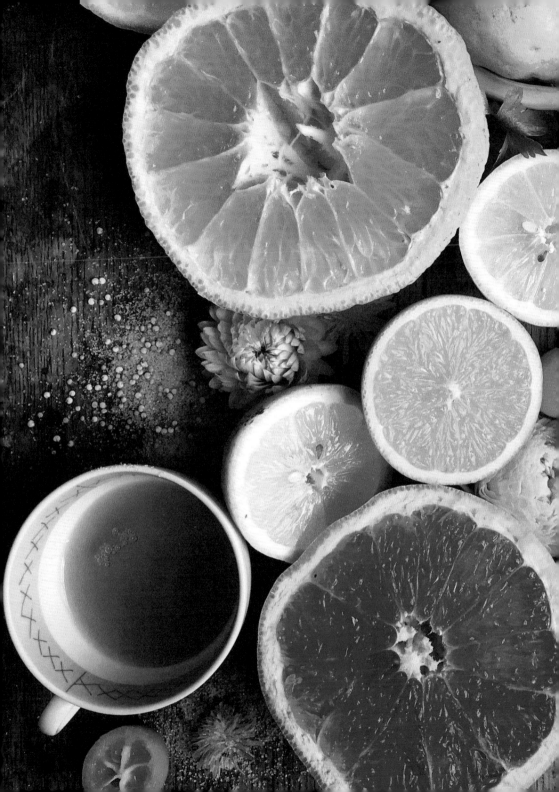

The Senses and Synaesthesia

Recruiting your senses to open
up an added level of creativity

There seems to be constant debate over the number of senses we possess: anything from the basic five to a staggering 33 and maybe even more. The precise number of senses doesn't really seem that important. It feels more important to acknowledge our perceptions of the senses so that we are able to enhance our experiences, interpretations and creativity connected to our environment. And this is something we can definitely practise.

'The senses are gateways to the intelligence. There is nothing in the intelligence which did not first pass through the senses.' *Aristotle*

In his philosophical works, Aristotle talks about *synaisthēsis*, a Greek word with a meaning comprising much more than just visual perception. It encompasses perception while recruiting all the senses, the impression that has on the body, and how that shapes and informs a person's interaction with the world around them. Aristotle talks about it as a 'common power' shared by all the sensations, but which cannot be simplified by any one of them. The term later took on a meaning that was much more akin to that of *consciousness*.

The Greek and Roman approach to experiencing the world through their senses is enviable and was obviously a way of being in touch with their surroundings that has been lost or diluted over many centuries. It may seem strange now to read that the Chorus in Aeschylus' *Seven Against Thebes* says '*I see the sound*', that the Roman agricultural writer Columella describes the '*green taste*' of olives or that Aulus Gellius, a Roman grammarian, describes the letter 'H' as green. In the ancient world the senses colluded and informed one another in a highly collaborative way. Simple objects would be read with *synaisthēsis* and appreciated with the same sensibilities that the Greeks and Romans had for all the arts. It seems that our modern, scientific understanding of synaesthesia has possibly reduced an integral part of Greek and Roman life to a mere anomaly.

One of my favourite books as a child was *Little Bunny Follows His Nose* by Katherine Howard. It was a scratch-and-sniff book, and Little Bunny simply allowed his sense of smell to lead him towards discovery. It's important to let your senses lead

you creatively and, whether that's connecting directly to synaesthesia – seeing colours, shapes and textures working in tandem with your senses – or simply utilizing your senses to stimulate new ideas, time spent allowing them to have that space to inform you will often feel like an exciting new discovery.

Synaesthesia is a merging of the senses: it's almost as if the senses are fused together or that they've somehow not separated sufficiently at some point. This precipitates the sensory mixing and overlapping. When experiencing sounds, tastes or smells, the brain stimulates corresponding visuals. Not static visual images, but ones that are edgeless, with movement and flow – something like the end of a firework being carried away on the wind. Colours bleed into forms, abstract shapes and familiar textures have the ease and rhythm of everyday thinking. But synaesthesia doesn't ever feel special. It is nothing magical or spiritual, it is just there and is something that feels as natural as your limbs.

There is great discussion as to whether we are all born with synaesthesia or whether this overlapping of the senses is something experienced only by a few people. I am convinced we all have a share of synaesthesia, but that some people have an ability to access it more readily than others.

Knowing colours of sounds may not be a necessary tool in the world of business or politics, particularly as it is so subjective, and without a use synaesthesia will certainly become redundant or virtually extinct. It's no surprise, then, that a huge majority of synaesthetes appear to have chosen careers in creative industries, possibly where their synaesthesia is actually harnessed. I would argue that the broader, more abstract visual landscape that synaesthesia provides would surely prompt more lateral thinking within less conventionally creative industries and lead to much more thinking outside of the box.

Whether you think you have synaesthesia or not, I want to give you some simple prompts to get you thinking in a more abstract way and connecting to your personal inner synaesthete. Most people have some sort of relationship to numbers or days of the week. Thursday might be pink, 40 might be brown, the letter A could be red and there may perhaps be a particular shape you categorize months of the year by. These won't be things that you usually consider, but if someone says that Thursday is pink and you know for sure that it's not, even if you don't know the reason why, then you are definitely connecting to your synaesthesia on some level.

There are many famous creative syntesthetes, such as Wassily Kandinsky, David Hockney and Georgia O'Keefe, while other artists, such as Mark Rothko and Vincent van Gogh, who may or may not have been synaesthetes, created work that often triggers sensory reactions.

Animator Norman McLaren made short films with synaesthetic qualities, which incorporate sound he created directly from visual marks he made onto celluloid film, giving us a great example of how sound can literally be a shape. His films *Dots* (1940) and *Synchromy* (1971) are fascinating studies in sound, shape and colour. There is also an episode of Oliver Postgate and Peter Firmin's animated children's television series *The Clangers* from 1972 where the Clangers find a bag that produces sound in abstract moving shapes and textures.

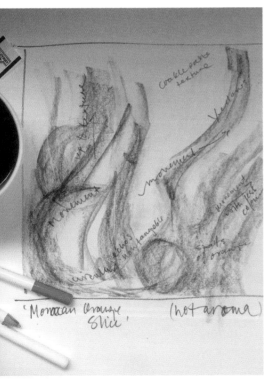
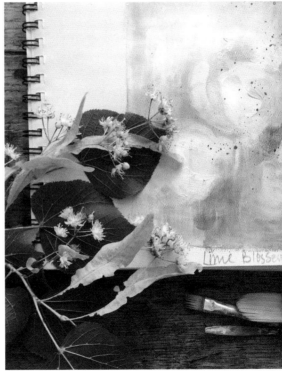

Sensory collecting

A significant part of daily practice always involves observation and collecting of visual information. I want to focus again on collecting, but this time with the aim of gathering sensory experiences. Documenting sensory experiences is not as simple as documenting texture and colour, and will involve finding alternative ways to store your experiences, as there are no devices (yet) that can keep a visual record of how we perceive smell, taste, touch and sound. This is actually a creative bonus because finding ways to keep notes of what senses you are connecting to will form a very distinct part of your personal process. How we interpret our senses is very subjective; there is no universal language that everyone understands and that describes our experiences. Birdsong might be golden or it might be purple. Some people might smell orange textures, some might smell green shapes or even nothing at all. It is completely dependent on who is having the experience. The two images below recall different scents: lime blossom (left) and a favourite perfume. Whether you collect in abstract-visual or information-led ways is entirely up to you; just choose whichever way you find most useful and accessible.

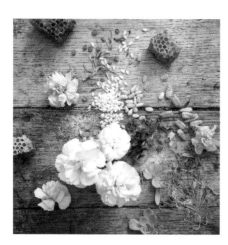

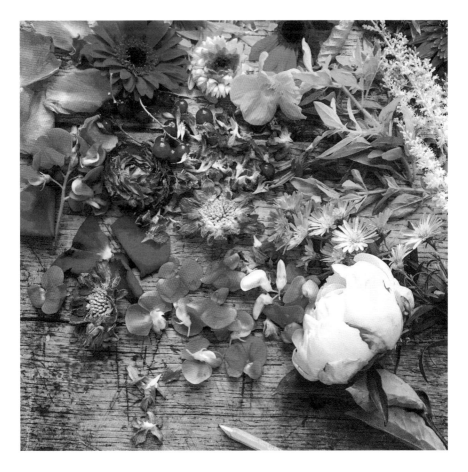

Taking time to experiment with the senses will start to lead you towards a much richer creative energy, a more conscious engagement with the world around you, and it will give you an exciting new resource for ideas. The exercises that follow are meant to help you experiment and can also be used in an interchangeable way between each of the senses.

Hearing and sound

I recommend you start with this exercise because listening to sounds is often more immediately accessible than the use of the other senses. It's about creating the space to hear in a way that connects you to the daily soundscape surrounding you. Allow yourself about 15 minutes on your own to complete it.

- Lie down or sit in a chair with your eyes closed.
- Create a blank space in your mind (it may be helpful to imagine a large empty room) and start to listen to the sounds around you. Focus in on the most predominant sound, which might be anything from your next-door neighbour's loud television to birdsong, or something going on in another room. Isolate this sound, whatever it is, and try to remove any emotional connection or association with it. Try to avoid using words to describe the sounds, regarding them more like matter or form.
- Take the sound that you have isolated and place it somewhere in the blank space that you have created in your mind. Once it has a position, focus on the less obvious sounds around you; maybe the washing machine, traffic or the weather. Find a place for each of these sounds to be added to the aural landscape you are creating.
- Now try and listen to any ad hoc sounds that appear: the creak of a floorboard, the distant thud of something unexplained or a sudden flurry of sirens. Where and how do these appear in your aural map?
- Finally, once you have found places for all the sounds you are experiencing, take some time to examine them with your mind's eye. It doesn't have to be anything that you can literally see; it can be more like a sense of knowing what it is without being able to explain it. Observe which ones feel stronger and more distinct, which ones are recurring or intermittent, and which ones you realize you enjoy.

It may be useful to make notes afterwards of what you experience, with either words, diagrams or sketches. You could also use found images to help you recall sounds. If you practise this exercise on different days and in different locations over the period of a week. it will help you feel more connected to all the sounds around you and you will start to create a new layer of reference. Once you have completed the exercise a few times you can then start to practise it while out and about with your eyes open.

- Take a 15–20 minute walk on your own where you don't have to talk, take pictures or complete any chores.
- Again, create a blank space in your head where the sounds can be placed.
- Take note of the more overwhelming sounds first but also notice the sounds that are muffled, sharp or hard.
- You are creating a sort of sound collage in your mind and it can be useful to think of it almost like a long piece of music you're listening to – only that this is created by slightly different instruments.

Scent and smell

When I visited the oldest perfumers in the UK, Floris, they suggested I smell one of their signature scents: No.127, first blended in 1890, and worn by Winston Churchill and Eva Peron. It was extraordinary because I was suddenly aware that I was literally smelling the presence of Churchill. It felt so real and so personal, as if I was actually able to smell a ghost. Scent, in my opinion, is the closest thing we have to time travel.

Scent and smell are much less tangible than sound. The olfactory system provides more of an amorphous, indifferent continuum that can dance in and out of our consciousness, but which provides us with the most informative and connected sense of place and history. Smell provides an integral backdrop to our lives; it is the accompaniment to what is happening right now and can prompt a much more powerful and emotional recall than any of the other senses.

A scent can reduce us to tears in a moment, remind us of the happiest time of our lives or transport us back to our childhood. Pipe tobacco, lily of the valley, talcum powder or a mother's perfume can all feel significant at different times in our lives, but they are not things we can easily record or store. Concentrating on smell can be quite difficult, as often the more you concentrate the weaker it becomes. You can smell a favourite flower, but when you focus your attention on the scent for too long it just seems to disappear. Getting more in touch with your sense of smell requires a slightly different level of awareness. The reactions can sometimes feel confusing, almost as if you can sense that something abstract is going on inside your head, but you just can't catch it or focus on it properly.

Scent collecting

Here are a few exercises to help you experience and experiment with your sense of smell:

- Make a scent diary where you can catalogue scents and smells, at least three per day, which have piqued your interest over a period of a week. For example:
 Monday: Fresh bread, friend's hand cream, satsuma peel
 Tuesday: Coffee, scented stocks, wet jumper
 Wednesday: Under the sink cupboard, clean sheets, toast
- At the end of the week look back over the smells you have collected and recollect what you were doing and the feelings you experienced at the time you experienced each smell. Notice how that recall makes you feel.
- When you've completed the first task, your sense of smell will have been slightly sharpened, so now make a list of ten smells you can recall from your childhood and which, for whatever reason, feel significant. It can be anything from the smell of your Granny's chair to a family suitcase, the inside of a car, daffodils, soap or a lip salve. Anything goes, as long as it conjures up a memory.
- Collect at least five natural smells that have a reminiscent quality for you.
- Collect a selection of smells that have definite contrasts, for example, lemon peel and pencil shavings. Take time to consider their differences and see if you can place your observations, without words, into a blank space in your mind similar to the one you have previously created for sound. If a scent is sharp, for example, in which area does your mind's eye view it? Up or down, left or right? Notice if colour, shape or texture, in whatever abstract form, start to either drift into your consciousness or suddenly take over the space.

Taste and texture

Taste is something that everyone has a close connection with on some level, as it is both integral and pleasurable. However, taste is not easy to isolate because it is always wrapped up with the other senses. Eating and drinking cannot be experienced without a sense of touch, smell and even sound. The smell of food navigates us towards it and into it, the texture of food can determine how pleasurable the taste experience is, and sound complements and completes the sensory experience. Would a poppadom taste as good if it were silent?

The texture of some foods can also sometimes overshadow the taste. The taste of an avocado is very subtle whereas its texture is very prominent. If you add balsamic vinegar to an avocado, the whole eating experience is heightened because two contrasting food elements are working in tandem to highlight the other's best quality. And when all the elements come together – aroma, texture, taste and sound – eating becomes a multisensory, multilayered joy.

Taste combinations work in a not dissimilar way to colour combinations and we can regularly be deceived by what we think we already know, just as in Josef Albers' colour exercises. Remember the exercise in Chapter 6 in which you placed two squares of exactly the same colour on to different coloured backgrounds?

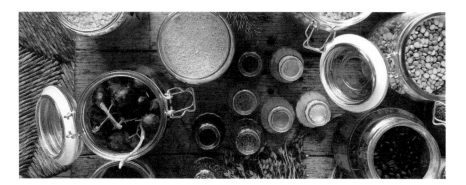

The coloured squares were transformed simply by the hue of the paper they rested on. Taste is the same; imagine cream cheese with smoked salmon and then that very same cream cheese with apple pie. Similarly to colour, tastes, and in fact all the senses, can enhance or destroy an aesthetic experience. Experimenting with taste is like experimenting with an artist's palette. The difference is simply that you are using a medium that you can only access in your mind's eye. The piece you create is not meant to be hung on a wall, it's meant to disappear from the plate.

I suppose that experimenting and being creative with taste is basically cooking, but I want to give you exercises to connect with the taste experience itself. Rather than just exploring the pleasures of eating, in this activity you will find a way of tasting that removes emotions attached to food and tries to examine what is left in their place. It is more like an investigation to reignite your taste curiosity.

Taste test

- Make a collection on a tray of about ten different foodstuffs. They should be bitesize pieces and a combination of sweet and savoury, as well as things you don't like, for example, crisps, oranges, eggs, celery, bread, olives, chocolate, prawns, coffee and tonic water.
- Take five minutes to really observe everything on your tray using your eyes, almost like you're trying to memorize it all.
- Now take at least a minute with each piece to really try and discover the taste, without writing notes. Acknowledge everything about it: what it looks like, its aroma, texture and sound, and then concentrate on what the actual taste is, or even if it has any at all.
- Make a mental note of any pieces that surprise you in any way at all and also if any disappoint you.
- Which pieces did you find most pleasurable texture-wise?
- Which piece had the best smell and which had the worst?
- Did any of their sounds surprise you, either before they were in your mouth or during eating?
- Choose two pieces on the tray that you would describe as opposites and think about the reasons why.
- Make notes on each of the pieces by making some sort of diagram, map or visual note that doesn't involve words or photographs.
- Now try to describe each of the pieces in just one word, even if you have to make it up.

'Eating is the only thing we do which involves all the senses. We eat with our eyes and our ears and our noses.' *Heston Blumenthal*

Feeling and touch

We have explored feeling and touch a little in the 'Taste and texture' section, but our sense of touch is something that should also be investigated independently of the other senses. Our skin is not only protective, but it is also massively informative and our hands are among our most useful means of discovery. I was staying with a close friend who had gone blind, and I was concerned that she couldn't find something in the kitchen; her hands were touching everything on the worktop, so I asked what she'd lost. 'I haven't lost anything,' she replied, 'I'm just looking.' Having lost her sight, her fingers had now become her eyes.

Exploring how we touch and feel our environment is an integral part of a creative process and, again, brings our consciousness closer to our surroundings. We can sometimes be almost phobic about touching certain things and then, conversely, we are desperate to touch others. I've often found myself at art galleries longing to touch paintings and if someone said I was allowed to touch Van Gogh's *Sunflowers* I know I would grab the chance. But dragging your nails down a blackboard, putting cotton wool in your mouth, or for me, running my hand along a nylon carpet, are examples of touch that some people fear.

Derived from the Greek word '*haptesthai*', meaning 'touch' or 'contact', haptic relates to the way in which humans interact by touch with the world around them. Haptics is the branch of psychology that investigates sensory data and sensation derived from the sense of touch localized on the skin. In recent years haptic technology has completely revolutionized our digital world with the understanding that we learn much more from touch than we previously thought. There is even a rumour that haptic technology will soon allow us to *feel* the person we are calling by means of a physical illusion that provides tactile feedback.

I want to encourage your sense of touch in this section while at the same time exploiting your curiosity. Allowing yourself to be curious enough to touch all sorts of things will undoubtedly feel childlike at times because it is one of the vital methods used by children to gain new information.

Identifying and collecting textures

- Allow yourself to touch at least ten different textures in a week – things you wouldn't have normally gone out of your way to touch. For example, flaky wall paint, the leaves of a bush, the door handle to an unknown room, a stranger's coat or a tree trunk. Make some simple visual notes about what you touched.

- Make a collection of substances that feel different from one another, for example, salt and a chunk of toffee, or a furry glove and an ice cube. Spend time touching one and then the other to discern your personal responses in detail.

- Take a large flower with lots of petals and allow yourself to slowly take it apart, petal by petal, leaf by leaf and stamen by stamen. Take your time to consider how every single part feels on your fingers and maybe on your face. Try to identify textures that you can't find a word for.

- Create a collection of about ten textures from around the house and then, blindfolded, mix them all up and start to explore each one using your fingers as eyes.

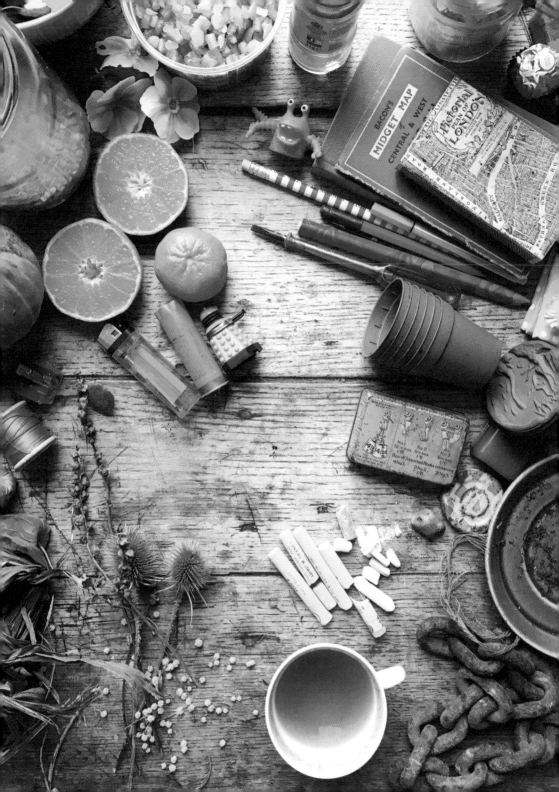

Create a sensory story

From all the different daily practice exercises, identify something connected to each sense that you really enjoyed. It could be a special taste, scent, sound or texture. Collect together all the elements you need and create some sort of sensory map that triggers an element of story. You are basically creating a sensory palette that you can extract imaginative ideas from, without the burden of reason. Any ideas, even rudimentary, will come from your sensory experiences and involvement with the objects.

A list of a few objects that may spark your senses:

Pebble	*Pencils*	*Wood*	*Paper*
Sandpaper	*Popcorn*	*Glass*	*Leather*
Felt	*Soap*	*Gravel*	*Hard plastic*
Furry hat	*Grapefruit*	*Banana*	*Fizzy water*
Shell	*Sugar*	*Cardamom*	
Marbles	*Cheese*	*Sticky tape*	

Chapter 8

Atmosphere and Nothing

Embracing the silent mass and stories
held in our surrounding spaces

You don't have to be totally conscious to create. Doing nothing, being bored and even sleeping can play a significant part in the creative process. So, this chapter is about allowing yourself to do nothing.

Everything is infinite nothing – our ideas, our time, our food – and we are all part of that nothing, but nothing will always lead to something. There is importance in a sudden silence because of the sound stripped from it. The start of an overture is made significant by the silence that immediately precedes it, the beauty of a freshly opened rose is informed by its recent unopened state, and the blank page at the beginning of a book is almost the most exciting one. There is a lot to be said for embracing nothing, particularly after vigorous periods of *something*, and doing nothing may actually help you find the *something* you are. We all need a bit of empty space to clarify and focus the world of possibility ahead.

'A nothing will serve just as well as a something about which nothing could be said.' *Ludwig Wittgenstein*

It's pretty well known that creativity functions best with periods of incubation, but it can be really hard to integrate this nothing time into your work practice. However, it is vital unconscious time when our minds are able to rework elements or problems that have arisen through conscious activity and which, more often than not, result in new and fresh ideas. I've always felt a bit guilty about my regular half-hour afternoon naps, partly because I'm so conscious that I'm not *doing* anything and it often feels more like I'm escaping. But sleep has been shown to be a very significant part of the creative process which utilizes intuition and insight and which leads you down a much more successful path to problem solving. Therefore, this proves that not only is nothing actually something, but it is in fact crucial.

Thinking about atmosphere presents a similar observation: it is full of something we feel, but at the same time absolutely nothing we can see. It is an essence. It is both something and nothing woven into time and place that can only be captured by feeling and suggestion. We ourselves complete an atmosphere. Atmosphere is about what your imagination is allowed to create beyond what you initially see.

In order to create a sense of atmosphere, whether it's in photography, painting, writing, composing or anything else, we have to spend time not only with our observations, but also with the *feelings* those observations bring. We need to soak things up emotionally as well as aesthetically so that we learn how to observe the way things make us feel and acknowledge the importance of that process.

Try to allow yourself to let go of wanting or needing to create anything for a while. It could be a day, it could be a week, but you absolutely need some days of nothing to be able to move forward.

Daily Practice: On doing nothing

There's an element of doing nothing in the exercises in the senses chapter, although there is an active notion of collecting connected to them. The exercises below are not meant to have any final product. They are ways of giving your brain a break from any *doing*, in order for ideas and experiences to be mentally digested and connected.

Sit

- Sit in a comfortable chair or on the sofa for 15 minutes.
- Do nothing apart from listening and looking.
- Don't fall asleep.
- Be aware of your surroundings but not distracted by them. (*There's no need to prepare or change anything around for this exercise.*)
- Be aware of your thoughts but not distracted by them.
- Allow yourself to stare into nothing.
- Allow yourself not to analyse this exercise.

Wash up (even if you have a dishwasher!)

- Collect all the day's washing up and organize it by the side of the sink.
- Fill the sink or bowl with water and washing-up liquid. Watch it fill up.
- Don't wear rubber gloves.
- Remind yourself that this is an exercise not a domestic chore.
- Wash it in categories, for example, glass, cutlery, plates, mugs, bowls, pans.
- Don't do it as fast as you can, do it so you know that each piece is clean.
- Allow yourself to think about how your wet hands feel and what the washing up sounds like.
- Dry everything individually with a tea towel.
- Put each piece back in its cupboard or drawer.
- Empty the sink.
- Dry your hands.
- Go and do something else.

Have a hot drink

- Put the kettle on and, with no one else around, make a cup of tea.
- Sit down at a table with it while it's still too hot to drink.
- Watch the steam for a while.
- Look out of a window while you wait for the perfect drinkable temperature.
- Carry on looking out of the window while you drink it.
- When you've finished it, look out of the window for five minutes more.

'The aim of art is to represent not the outward appearance of things, but their inward significance.' *Aristotle*

On atmosphere

As I mentioned before, atmosphere, and the ability to capture it, relies on your ability to sense and feel it emotionally. To soak up an atmosphere is to be present and aware of something wider than the detail of the subject you are focusing on. Atmospheric images are massively influenced by light and shadow, and although you can recreate an atmosphere with artificial lighting, music or words, you can't conjure that all up from nowhere. You must have had some conscious atmospheric experiences to be able to creatively draw on them yourself. It's possible to have beautiful and interesting subject matter that can be greatly admired, but if you include atmosphere, you allow your audience to feel far beyond mere admiration.

'Beware of that which is breathtakingly beautiful, for at any moment the telephone may ring...' *John Cage*

As soon as a figure is added to a landscape there is story; and a solitary, swaying curtain will give narrative to an empty cabin. Atmosphere is the untold story we can all create from the space a story rests in and it will often be the defining element that makes your work unique. We gain a sense of how an artist perceives the world from the atmosphere they choose to share with us. Emulating work by other people can be useful technically, and also very satisfying, but it will never serve to develop your own sense of atmosphere.

I had a teacher at drama school who told me that every time I went on stage my character should always have a secret – a secret I had invented; one that wasn't in the script and one that was not displayed or divulged to anyone, at any time. He said it meant the character would always have atmosphere, life beyond the stage, beyond the play itself, and this would make a performance unique. I now apply this to my images. I create small secret stories that only I know and which sit silently in the space between the viewer and me.

Daily Practice: Sensing atmosphere

Using music

A very easy gateway into experiencing different atmospheres through your imagination is by listening to music. Music has the magical capacity to transform a moment of terror into a moment of romance.

Create a playlist of various atmospheric pieces of music. It's often helpful at first to find purely instrumental compositions so you aren't distracted by any lyrics. You should make sure you draw on a diverse range of sources so that you can call on them to inform your storytelling and atmospheres. These are some examples you could listen to that cater for different moods:

Light: Vivaldi – *Op. 8. Spring: Allegro*
Dark: Ingram Marshall – *Fog Tropes*
Uplifting: Holst – *Op. 3. Jupiter, the Bringer of Jollity*
Romantic: Vaughan Williams – *Fantasia on a Theme by Thomas Tallis*
Ominous: Morricone – *Once Upon a Time in the West*
Pensive: Rodrigo – *Concierto de Aranjuez: Adagio*
Happy: Mozart – *Piano Sonata No. 11 in A major*
Sad: Mahler – *Symphony No. 5 in C sharp minor. IV Adagietto*

Using places

Try and notice small atmospheric moments within your normal daily life, whether it's a solitary person sitting on a park bench or the madness of a busy office. Be alert to the varying and contrasting atmospheres you experience within one day. Atmosphere can change even between aisles in the supermarket; the bread aisle is often calmer than the fruit and veg aisles, for example. Busy shops, empty roads, libraries, bars, woods and beaches; they're all great places to consciously soak up different atmospheres.

This is the chapter where there isn't something to *show* for your experience. The exercise here is simply to reach a stage where you are more aware of atmosphere by observing light, sound and visual image so that you start to notice not the detail, but the silent mass that surrounds it.

Make notes, draw sketches and take photographs as and when something feels important, but don't feel that it is a necessity. Sometimes we just need to do nothing in order to give our heads the space to process things. Just being and getting on with boring, everyday stuff is, at times, very beneficial to the whole creative process.

Chapter 9

Light and Shadow

**Seeing beyond the obvious
and feeling the darkness**

I think I have always had a wariness of shadows. Shadows can be frightening; an unknown quantity, harbouring threat and *shadowy* characters. But shadows are part of life, both aesthetically and spiritually. As silence proves the sound and pausing proves the act, it is always darkness that proves the light. An acknowledgment of shadow – its sense of mystery and depth – can transform a dark corner into a piece of poetic, captured atmosphere. Shadow connects you to thought, meaning and seeing beyond the obvious, and as someone exploring personal creativity, it is important to take on board its great significance, its quiet yet integral presence.

In Praise of Shadows by Junichiro Tanizaki is one of my favourite books and is a wonderful study on the significant part shadow plays in Japanese culture. It covers the cultural importance of shadow, from the ancient custom of teeth blackening to the aesthetic significance of lacquerware over ceramics as well as the tokonoma (a recessed alcove), which is the spiritual centre of the traditional Japanese home.

We have become so used to making everything brighter; turning on lights and illuminating our world. But if we look back and consider how shadow would have been a much larger part of our lives before electricity, that in itself is illuminating. Before electricity, the beauty of a Japanese room was judged on its shadow play; delicate colour and shade differences, sometimes only appearing to exist through the mood of the viewer, accentuating intentional combinations of natural light and interior design. Being able to sit and consciously consider – even work in tandem with – the subtle beauty of natural shadows slowly appearing and disappearing with the ebb and flow of the day, must lead to an inherently contemplative way of observing life.

'We find beauty not in the thing itself but in the patterns of shadows, the light and the darkness, that one thing against another creates.' *Junichiro Tanizaki*

Investigating the magic of shadows is, in my opinion a skill that is as important as noticing everyday brightness and colour. It is an essential part of training your brain and your creative eye. Atmosphere itself is '*a surrounding environment or influence*' and therefore very difficult to create unless you have a sense of shadow.

Noir films like Carol Reed's *The Third Man*, David Lynch's *The Elephant Man*, and Akira Kurosawa's *Throne of Blood* are all great examples of how integral shadow can be to the whole feeling of a film.

Contrasts also focus the beauty in shadows and can help to set our eyes on its mass rather than the notion of its transience. I want to encourage you to appreciate what shadow invokes: new forms, silhouettes, calmness and a silent, soft transforming of light. Shadows always subtly remind us that everything has a finite time to glow.

Shadow collecting

Making a personal collection of shadows is really useful and often quite thought-provoking. A camera will also help you to actually see the shapes of shadows in front of you, allowing you to look at things almost with an extra eye. Shadow spotting can be a bit like one of those *Magic Eye* optical illusions; you have to retrain your eyes and look in a slightly different way in order to see the hidden shapes, not the solid objects, and the dark spaces in between. Collecting shadows opens a door to a dark and fascinating world of nooks and crevices that you've never previously noticed.

The shadows you collect should vary: they don't have to be crisp silhouettes created by bright sunlight or composed atmospheric shots, they can be small shadows in corners, hazy shapes on the table or leafy patterns on the pavement. While the image you take can have a context, it is not essential. Observing the contrasts of light and shade near windows and doors is always a good place to start, but also try and find the more abstract shadows.

 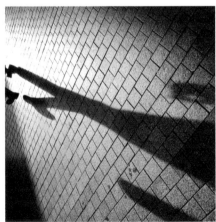

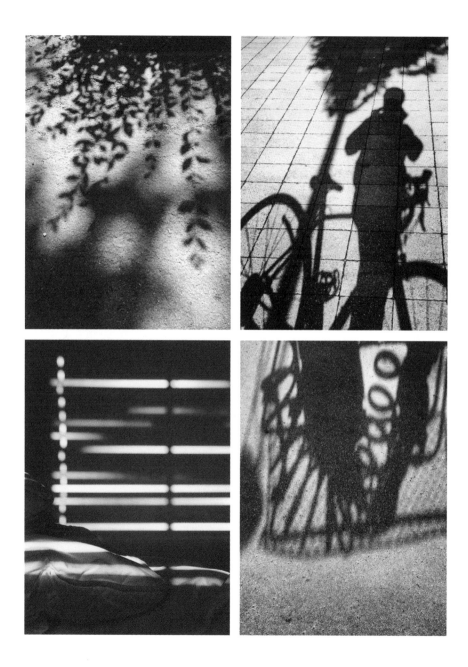

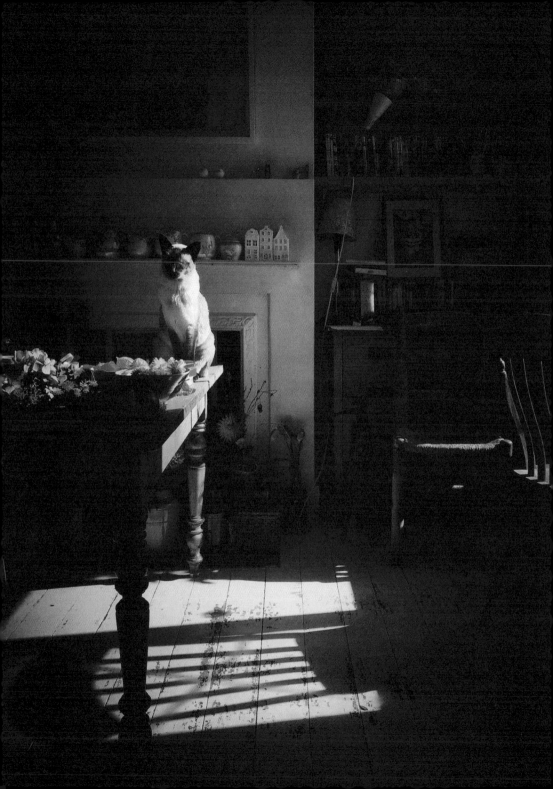

Daily Practice: Create a shadow story

Collate a series of at least six images utilizing shadow, to create a visual story that accentuates or narrates some sort of atmospheric journey, even if it's a journey only you understand. Be led by what you see rather than having any pre-prepared ideas and let the narrative be as abstract or as linear as you want. The idea is to get you to engage with shadow and embrace it as a useful creative tool, and taking photographs is one of the best ways to capture these fleeting details. Investigate and experiment and, as ever, remember this it is not an exercise in perfection.

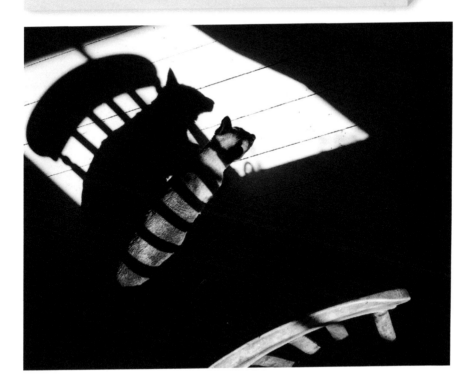

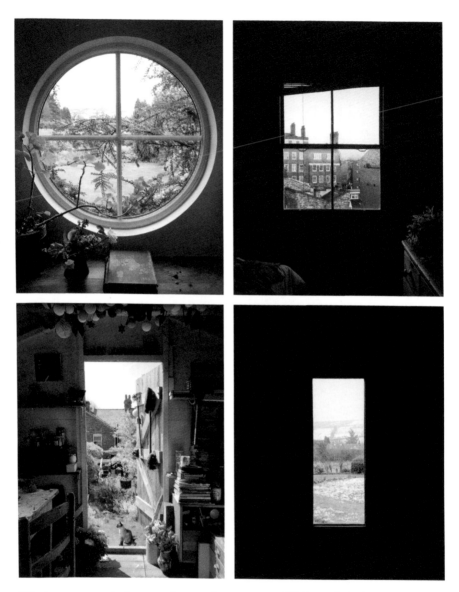

Windows are great places to observe the contrasts of light and shadow.

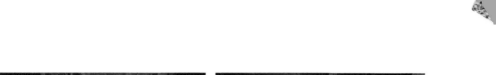

It's also useful to look for how colour can inform, combine with and punctuate shadow in a slightly different way.

Abstract

Identifying shapes, forms, spaces
and patterns in everyday life

Expression Through Image

When I was 19, a friend doing an Art Foundation course gave me a copy of John Berger's *Ways of Seeing*. When I came to his visual essays I was so deeply relieved to have found someone who gave weight to a collection of images designed to be 'read' that I realized, in that moment, I only ever wanted to compose visual essays to express my thoughts.

I strongly believe that by involving and connecting yourself to the world around you through abstract form and thought, your mind will become open to seeing much more than words are able to describe. There is so much to look at both inside and outside our minds that can only ever be communicated through image. However, simple expression through image and abstract thought is often undermined or patronized by some who live on words and wit. But emotion can't always be expressed in a cerebral way and maybe some days an explosion of pink daubs on a blank canvas says it all.

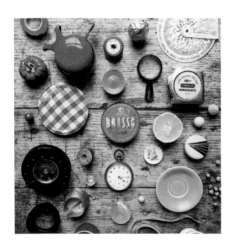 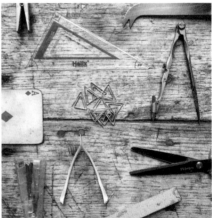

Form

My art teacher would admiringly gasp at pictures of Giotto's frescos – his cloth-covered kneeling figures that had 'such weight and form'. I felt embarrassed because I didn't really get it like she did and was relieved when we moved on to Hogarth's *Marriage A-la-Mode* with its satire, story and detailed commentary on society. But it stuck with me: *form*. Why was it such a delight to her and why couldn't I appreciate it?

Over the years, my appreciation of shape and form has grown alongside my passion for the abstract. Images with an element of weight and movement appear to have great presence and I now find it very satisfying to look at work with forms that somehow anchor emotion and are bold, expressive and simple.

Shape

My art teacher also told us to study shapes. Shapes around things, shapes between things; the negative as well as the positive. Looking at shapes, forms and patterns is fascinating and shares a strong connection with the abstract. Once you realize the shape or the inverted shape of an object, disregarding its actual purpose, abstraction becomes compelling. You start to see the abstract form of everything around you and realize how simple it is. When it comes to visual composition, the ability to notice how abstract shapes can inform or distract is an integral skill. Whenever I compose an arrangement I not only use interaction of colour, but I also always use an interaction of shape, both positive and negative.

We've covered some of the elements below within previous chapters, but before moving on to composition, I want to embed an extra layer of exercises to help you look at things in slightly different ways. In this way your tool kit will be even more comprehensive, with easy routes to inspiration. The more you observe, the more you notice and the more you notice, the more inspired you will feel. All these exercises are meant to slot together; pattern spotting blends into abstract spotting, as does matching.

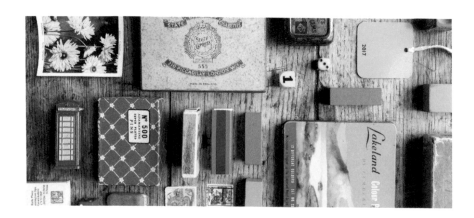

Daily Practice

1. *ABSTRACT SPOTTING* is a practice of noticing the form of shapes out of context and a simple viewfinder or mobile camera is incredibly helpful for framing abstract shapes.

2. *MATCHING* is a practice of looking out for objects, forms or shapes that visually match others closely, but are functionally completely different.

3. *SYMMETRY AND PATTERN SPOTTING* is a practice of consciously noticing and actively looking for pattern connections, no matter how random or abstract. You will become more adept at spotting patterns the more practised you become.

Top left Abstract by artist Tomie Ohtake. (Tomie Ohtake, 1964. Oil on canvas, 135 x 100 cm. © Tomie Ohtake)

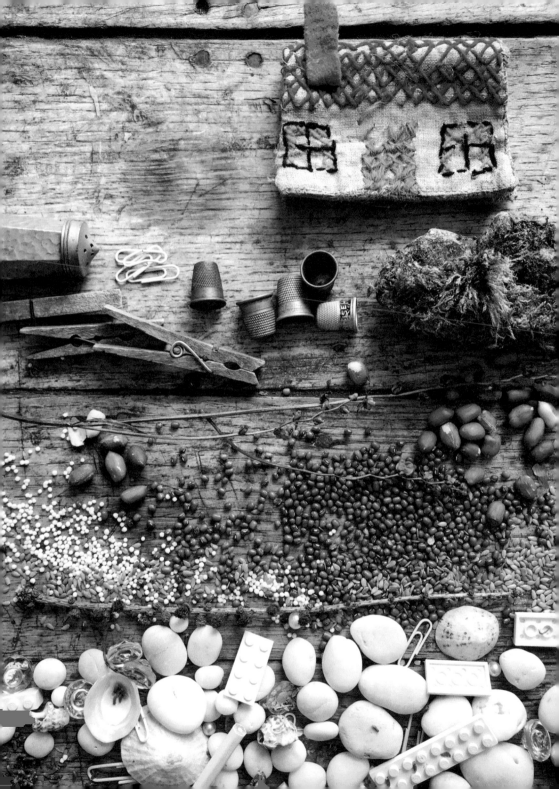

You can also keep a lookout for similar patterns or compositions when you're out and about. The idea is to identify and familiarize yourself with shape and form. Play around with it and see where it leads your imagination.

Also, try turning the exercise on its head and recreate something abstract from something more literal, like a landscape, which you might have seen out on a walk.

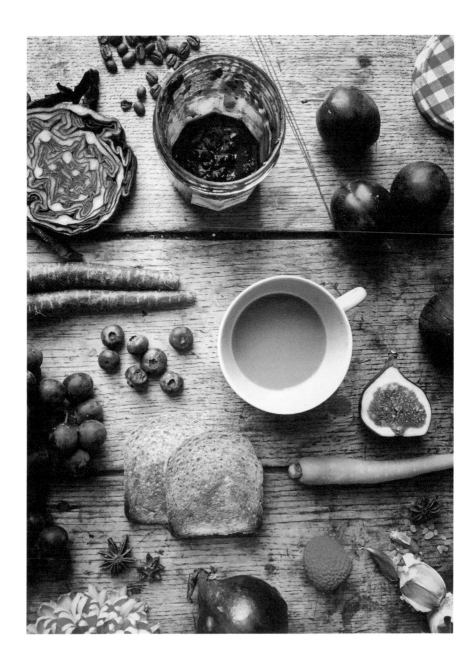

It's really important to keep practising observing shape similarities and colour connections. Seeing shapes and colours without the burden of thinking about what they are will liberate your creative mind, inform your visual resources and alleviate intellectual interference.

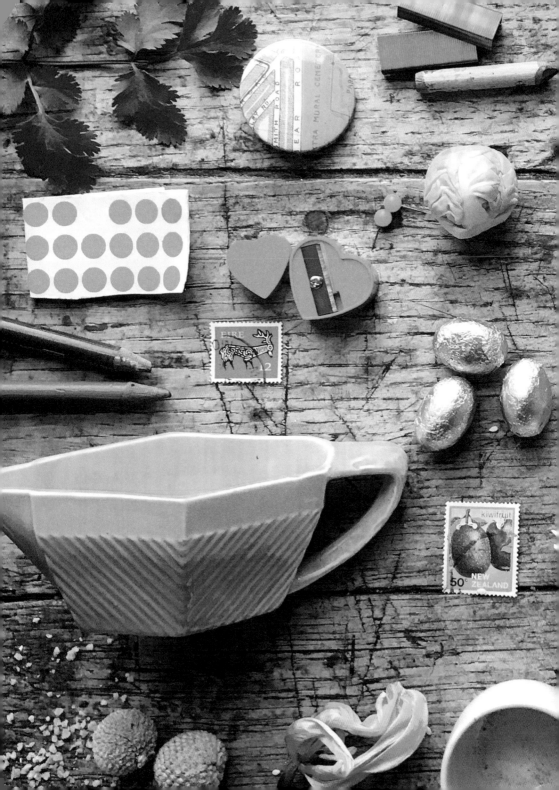

Composition

Creating your relationship to objects and places
through experimentation and experience

There are rules which, if you follow them like a recipe, will probably mean that you'll be able to create a good composition. Rules can be a very useful starting point. But rules can also leave little space to organically grow your interaction with the world and the way you want to express yourself. Our enthusiasm and freedom to create can often feel restricted because the pressure of rules can make us feel that we're just not getting it right. To have a comprehensive and rooted understanding of your surroundings, colours, objects, shadows, shapes, textures and natural rhythms, will lead you to clarifying, much more imaginatively and successfully, your inspiration as form.

When I was at drama school we had method-acting classes. Students became obsessed with it – only eating potatoes, drinking Pernod and walking around in painful shoes because their character did. While I saw, and still can see, the use and focus for it, it also appeared at times to be a little imposed. One Saturday morning, a student was in meltdown after he'd left his 'character music' on the bus and our teacher growled at him, 'Look, The Method is there to *help* you, not to control you. Use your imagination!' It was a turning point for me to know that it wasn't all about doing it by the *rules*. It's your imagination that sets you free and sets you apart.

'Consulting the rules of composition before taking a photograph, is like consulting the laws of gravity before going for a walk.' *Edward Weston*

So, I'm not going to explain the Rule of Thirds or the Golden Ratio here. All the observational exercises in the previous chapters cover fundamental elements that hugely inform composition, such as pattern, shadow, shape, light, atmosphere, colour, and positive and negative space. The whole purpose of this book is to enable you to look at things in an alternative and more substantial way, so that you arrive at composition through genuine interest, experimentation and experience.

Keep looking, reading and listening to other artists' work – not always work you instinctively like, but a diverse range, because that way you will become both inspired by and saturated with good composition, which will then subliminally start to inform your own work.

Creating a 'finished' piece is much more intimidating than having freedom to play around finding composition at your own pace. A Japanese ikebana arrangement is always found, rather than planned: you find what is already there in nature and in yourself, and you incorporate both, the arrangement becoming a reflection of your feelings. Three main points that represent heaven, earth and humanity delineate the basic structure of ikebana, and I believe that those three elements are the key to all composition.

My personal style of flat lay composition is something more akin to that of an aesthetic, abstract anagram that has many possible correct answers. I'm emotionally led to consider each element individually, and then find ways that they can all work together for a successful outcome. Creating daily compositions on my table throughout the year is great practice and has served to inform many other areas of my work.

Through composition you guide someone's eyes and mind towards what you perceive to be the most important part of your piece. You take them on a journey towards what you have to say and how you want to say it. Good composition is a thing of magic which transforms ordinary objects and previously dull environments into thought-provoking art.

Ordering

Arranging ordinary objects and seeing how they relate to each other is a great way to practise composition. It allows you to experiment and consider small details, training your eye to focus on shapes, colours and textures. It also clarifies personal connections with basic, everyday things.

Ordering is an exercise in enhancing observation using a subtle compositional anchor. You'll often see small children organizing their toys and arranging their possessions into collections. It's an activity that can occupy them for hours. It's engrossing and calming, and it often leads to new ideas. Order can give objects more relevance and awaken fresh connections.

Daily Practice

- Choose something you have lots of. Pens and pencils, for example, although it really can be anything: cutlery, tools, make-up, dead leaves, stamps or even socks.
- Collect between 15 and 20 objects and roughly place or drop them onto a surface. Take at least five minutes just to really examine everything, but without touching anything. The unintentional shapes and patterns are often the ones that will lead a composition.
- Take the object that aesthetically appeals to you the most, or that has most significance, and place it in the middle of the space.
- Find the next object to place through instinct rather than meaning. It could be through colour or it could be through memory, but the key to ordering is always to look in detail at the objects in isolation and then try to find something that in some way matches another object. Think of the exercise as putting an abstract jigsaw together.

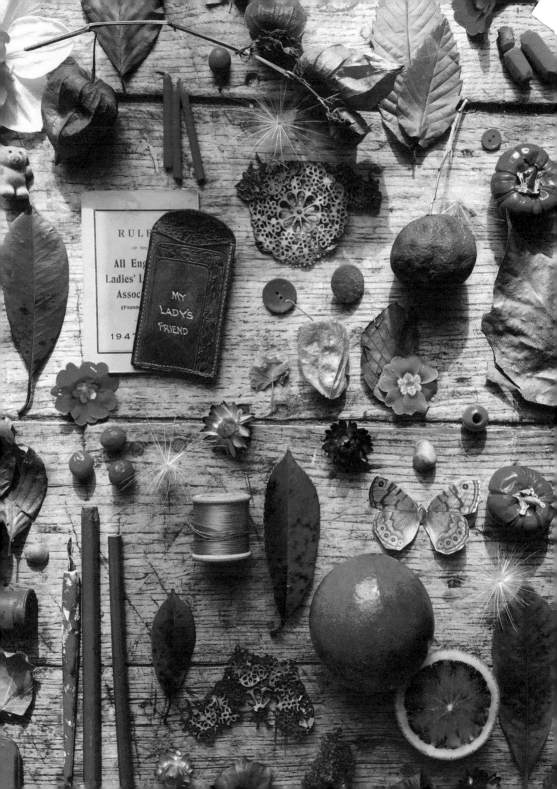

Composition as a springboard

- Create your own photographic composition inspired by something you have seen around you. It could be on a beautiful walk, a day out, shopping or even commuting. There is always composition waiting to be extracted from everyday life and there is always inspiration to be found.
- Consciously think about why you've chosen it, how it makes you feel and also whether it could serve as a creative catalyst for another project.
- Intentionally create something in response to the composition you found.
- Don't limit yourself to your usual, more comfortable mediums and try to experiment with sound, photographs, writing, drawing, collage and cooking.

All the chapters that precede this exercise have armed you with the resources to help you gain the confidence to be able to create something. Now composition is your freedom.

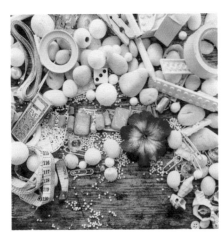

A simple checklist

Here are a few very simple points that are good to check if you need a bit of guidance; they're not rules, they're just things to keep an eye on:

- Decide exactly what you want the focus to be.
- Check the background for any distracting elements. Even the shape of negative space can lead the eye in the wrong direction.
- If you have lots of similar elements, try to remember that odd numbers always work better than even ones and using threes works particularly well.
- Using asymmetry carries thinking space and will always prompt an imaginative journey for the viewer.
- Find any natural lines you can use to *frame* an integral element or lead the eye towards the subject.
- Look for symmetry of shapes, textures and colours.
- Use opposites to highlight your focus.
- Make sure horizontals are horizontal. Getting something straight makes a huge difference.
- Actively look for obscure inspiration.
- Experiment!

'It's not about composition. It's the way you feel about how your objects should relate to each other.' *David Bailey*

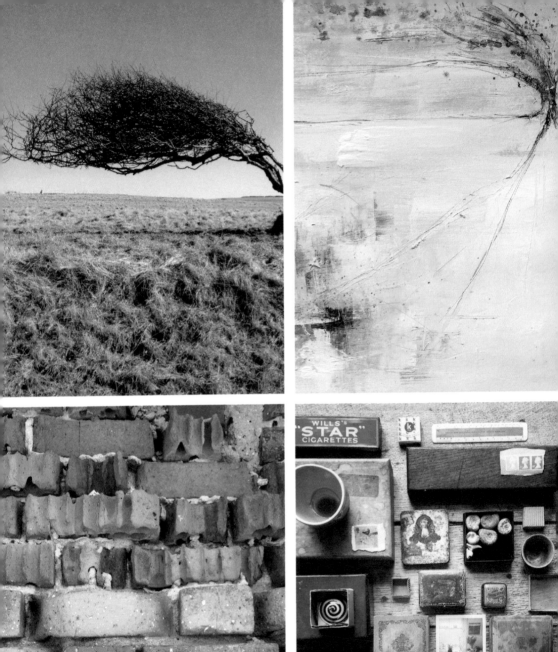

Chapter 12

Continuing Practice and Personal Projects

Finding your rhythm, finding your passion

Recap

When you reach the end of any kind of course or project, the thought of going back to the beginning is not very appealing; it's in the past, you've moved on and you don't feel very comfortable revisiting your starting point. But it is a really useful exercise which will help you recap and evaluate how your ideas or working practice may have changed, grown or even stayed still.

The exercises I've put together in this book are designed to be reworked many times so that they form part of a tool kit, a springboard into creative practice. If you want to keep fit, you don't kick it all off by running a half marathon; you build up slowly through training and time. You find your own rhythm, you defeat boredom and you work your muscles into a place that will take you to and hopefully beyond your initial goal. It's no different with creative practice, you're just working different muscles and heading towards different goals.

Find your passion

'Maybe my passion is nothing special, but at least it's mine.' *Tove Jansson*

It's almost vital to a continuing creative practice to find, invent or identify a personal passion, project, obsession or collection, because not only can it motivate and challenge you, it also means that even when you're feeling uninspired you will always have a go-to subject to connect with.

Apart from flat lay compositions, telephone booths have been one of my longest ongoing personal projects. I started taking photographs of them with disposable cameras when I was 19 and I couldn't have imagined that they would ever become a fast-disappearing and almost obsolete structure. They have been a constant source of inspiration, fascination and anchorage for me for more than 25 years.

It is much more important to be able to work deeper rather than wider, and a passion is essential to any creative; it fuels curiosity, experimentation, input and output, and serves as a great anchor in the sea of constant ideas that can forever float around your head. Your passion or obsession won't necessarily be your best or most lucrative idea, but it will be a rock and it will be *yours*.

'Though we pursue an economic value in life, it is in admiring beauty and creating things that we enrich the ground of our mind.' *Senei Ikenobo*

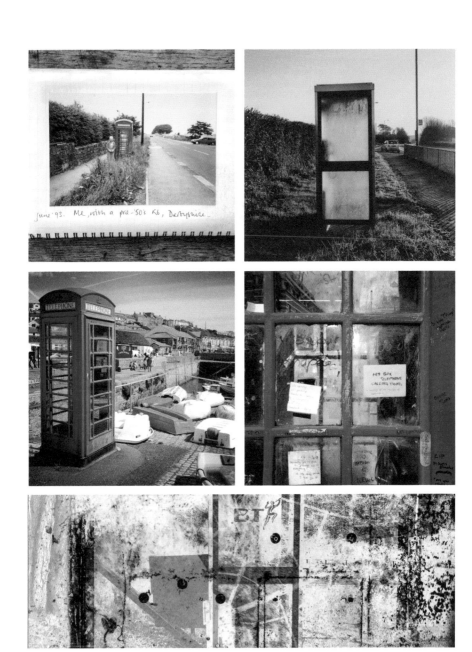

June '93. Me, with a pre-'50's K6, Derbyshire.

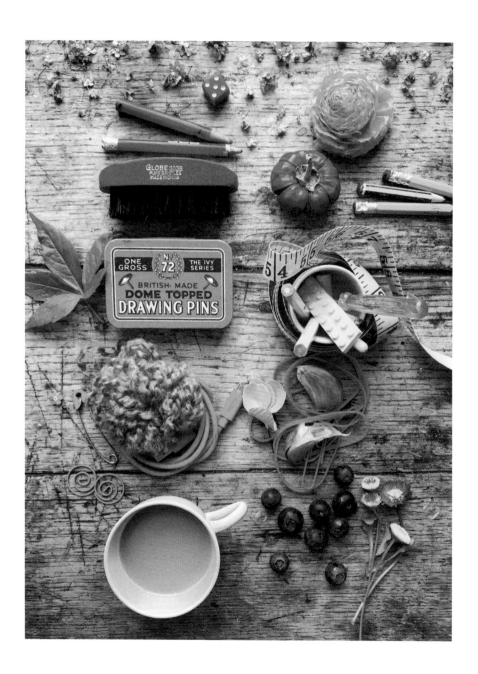

Seasonal inspiration

Spring
An exciting time creatively with so many new details emerging. A season of fresh smells, new sounds, bright, clear light and lots of blossom.

Summer
A season to find the scent of flowers, listen to birdsong, warm morning silences and afternoon bustle. There's such precision of colour and there are shadows in abundance.

Autumn
Autumn provides many different aromas so it's a season to consciously use your sense of smell. The light is bright yet soft and very ordinary places become swathed in colour.

Winter
This is a season of two halves; an exciting, cosy time of creativity followed by a slow wait before spring. Bare trees remind us that losing everything simply paves the way for fresh new life.

Resources

Books:

Interaction of Colour by Josef Albers (Yale University Press, 1963)

The Poetics of Space by Gaston Bachelard (Orion Press, 1964)

Japanese Flower Arrangement for the Modern Home by Dods Bebb (Collingridge, 1959)

Ways of Seeing by John Berger (BBC/Penguin, 1972)

About Looking by John Berger (Bloomsbury, pbk, 2009)

Björk by Björk (Bloomsbury, 2001)

David Hockney: Current Essays by Barbara Bolt, Edith Devaney, Martin Gayford, Bowen Li and Simon Maidment (Thames and Hudson, 2016)

Synaesthesia and The Ancient Senses Edited by Shane Butler and Alex Purves (Acumen Publishing, 2013)

The Art of Japanese Flower Arrangement by Stella Coe (Barrie & Jenkins, 1964)

On Being An Artist by Michael Craig-Martin (Art/Books, 2015)

Lateral Thinking: A Textbook of Creativity by Edward De Bono (Harper & Row, 1970)

Think Like An Artist Don't Act Like One by Koos De Wilt (BIS Publishers, 2017)

Curiosity: Art and The Pleasure of Knowing by Brian Dillon and Marina Warner (Hayward Publishing, 2013)

A Bigger Message: Conversations with David Hockney by Martin Gayford (Thames and Hudson, 2011)

The Story of Art by E H Gombrich (16th edition, Phaidon Press, 2007)

Everything That Can Happen In A Day by David Horvitz (Mark Batty Publisher, 2010)

Ikebana by Senei Ikenobo (Hoikusha, 1970)

Chroma by Derek Jarman (Century, 1994)

Wabi Sabi: For Artists, Designers, Poets and Philosophers by Leonard Koren (Imperfect Publishing, 2008)

Wabi Sabi: Further Thoughts by Leonard Koren (Imperfect Publishing, 2015)

Catching The Big Fish by David Lynch (Jeremy P Tarcher/Penguin, 2006)

Musical Paintings Edited by Malcolm McLaren (J R P Ringier, 2009)

The Book of Tea by Kakuzo Okakura (Duffield & Company, 1906)

Perfume, A Century of Scents by Lizzie Ostrom (Hutchinson, 2015)

The Descent of Man by Grayson Perry (Allen Lane, 2016)

Woman's World by Graham Rawle (Atlantic, 2005)

Reality Is Not What It Seems by Carlo Rovelli (Allen Lane, 2016)

The Secret Lives of Colour by Kassia St Clair (John Murray, 2016)

Gastrophysics by Charles Spence (Viking, 2017)

In Praise of Shadows by Junichiro Tanizaki (Cape, 1991)

The Frog Who Croaked Blue by Professor Jamie Ward (Routledge, 2008)

Tove Jansson Life, Art, Words by Boel Westin (Sort Of Books, 2013)

Films:

2001: A Space Odyssey - Stanley Kubrick, 1968

The Elephant Man - David Lynch, 1980

The Grand Budapest Hotel - Wes Anderson, 2014

Once Upon A Time In The West - Sergio Leone, 1969

Singin' In The Rain - Gene Kelly & Stanley Donen, 1952

Susperia - Dario Argento, 1977

The Third Man - Carol Reed, 1949

Throne Of Blood - Akira Kurasawa, 1957

Acknowledgements

This book was only possible with the help and enthusiasm of people who either sat on my shoulder throughout the whole process, talked to me for hours on end during long car journeys, or simply encouraged and accepted so many of my ideas: Sophie Abbott , Rachel Rice, Nikki Cotton, Jess Sims, Xanthe Berkley, Louisa McCarthy, Celia Nelson, Anne Robson, Julian Rea, Holly Bell, Emma Herian, Shyama Ruffell, Clive Stanton, Wes Stanton, The Cheeks, Kitty McGeevor, Alix Audley, Kristin Basta, Davorka Andjellic, Laura Dunkley, Emmanuelle Moeglin at The Experimental Perfume Club, Elizabeth Dalton, all the students from my first 'Consciously Creative' online course, Monica Perdoni, Joanna Bentley, Graham Robson . . . and Jane Hepper for always being there even when she isn't.

Index